INDICATORS
ARTISTS ON CLIMATE CHANGE

Organized by David R. Collens, Nora R. Lawrence, and Sarah Diver

Foreword by John P. Stern

**STORM KING
ART CENTER**

Published on the occasion of the exhibition
Indicators: Artists on Climate Change at
Storm King Art Center, New Windsor, New York,
May 19–November 11, 2018, organized by
David R. Collens, Director and Chief Curator;
Nora R. Lawrence, Senior Curator; and Sarah Diver,
Curatorial Assistant.

Indicators: Artists on Climate Change is made possible
by generous lead support from Roberta and Steven
Denning, Agnes Gund, the Hazen Polsky Foundation,
the Ohnell Charitable Lead Trust, and the Samuel
Freeman Charitable Trust. Support is also provided by
Janet Inskeep Benton, the Laurance S. Rockefeller Fund,
the Lipman Family Foundation, Mr. Tom Steyer and
Ms. Kat Taylor, and Sandra Wijnberg and Hugh Freund.
Support for the catalogue is provided by the Elizabeth
Firestone Graham Foundation. Special thanks to the
Natural Resources Defense Council (NRDC).

Edited by Libby Hruska
Designed by Pascale Willi
Production by Christina Grillo

Printed and bound by Trifolio, Italy
Printed on Igloo Offset 160 gsm
Interior printed on recycled paper

Published by

**STORM KING
ART CENTER**

1 Museum Road
New Windsor, New York 12553
www.stormking.org
indicators.stormking.org

Printed in Italy

Library of Congress control number: 2018948796
ISBN: 978-0-9991183-1-3

Front cover: Jenny Kendler, *Birds Watching*, 2018.
See pp. 50–51
Back cover: Meg Webster, *Growing Under Solar Panels*,
2018. See pp. 85–87
Endpapers: Dear Climate, designs for *General Assembly*,
2018. See pp. 30–31
pp. 4–5: David Brooks, *Permanent Field Observations*,
2018. See pp. 25–27
pp. 6–7: Mark Dion, *The Field Station of the Melancholy
Marine Biologist*, 2017–18. See pp. 34–35
pp. 8–9: Dear Climate, *General Assembly*, 2018.
See pp. 30–31
pp. 10–11: Mike Nelson, *Eighty circles through Canada
(the last possessions of an Orcadian Mountain Man)*,
2013. See pp. 66–67
pp. 12–13: Jenny Kendler, *Birds Watching*, 2018.
pp. 50–51
p. 14: Maya Lin, *The Secret Life of Grasses*, 2018.
See pp. 54–55

Credits
Photograph by David Brooks: p. 26 lower left
Photographs by Justin Brice Guariglia: pp. 42–43
Photograph by Maris Hutchison/EPW Studio: p. 79
Photographs by Jenny Kendler: cover, pp. 49–51
© Mike Nelson, courtesy of 303 Gallery, New York:
pp. 10–11, 66–67
Photographs by Tom Powel Imaging: pp. 81–83
Photograph courtesy Tavares Strachan: p. 80
Photographs by Jerry L. Thompson: back cover,
pp. 4–9, 12–14, 22–23, 25, 26–27 (top row and bottom
center and right), 30–31, 34–35, 42–43, 46, 47, 54–55,
58–59, 73–75, 85–87, 90, 91
© Meg Webster, courtesy Paula Cooper Gallery,
New York: back cover, pp. 85–87

CONTENTS

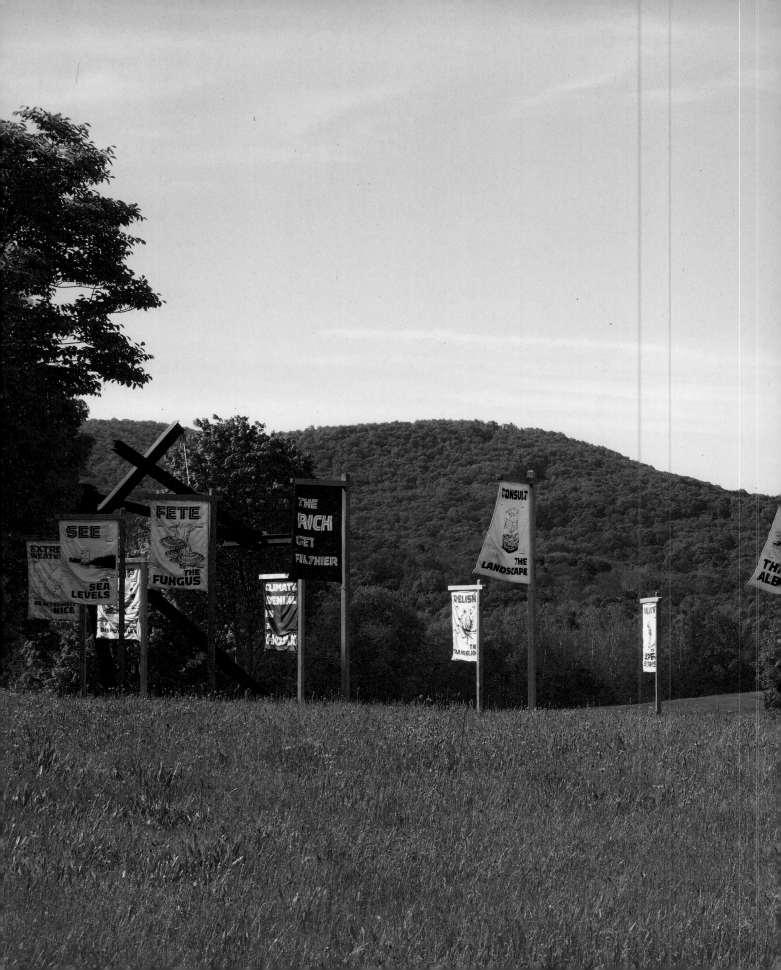

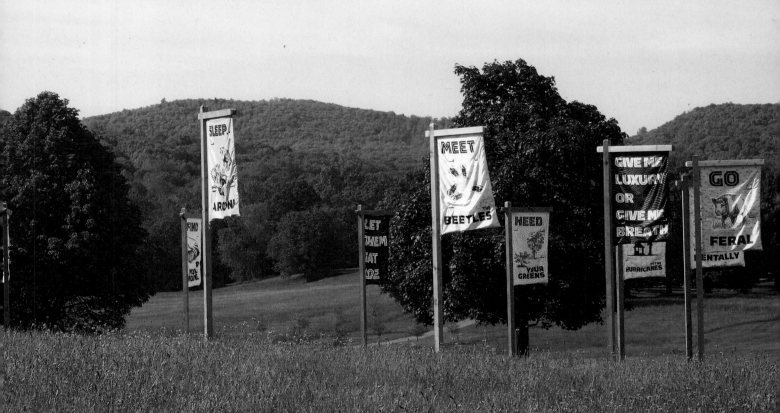

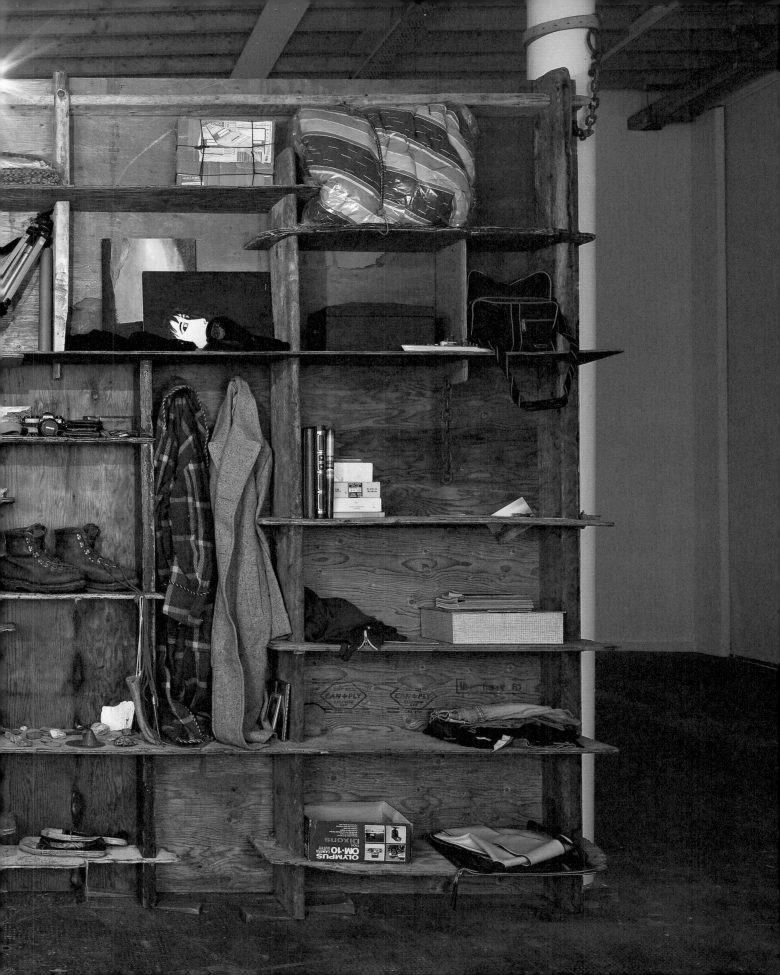

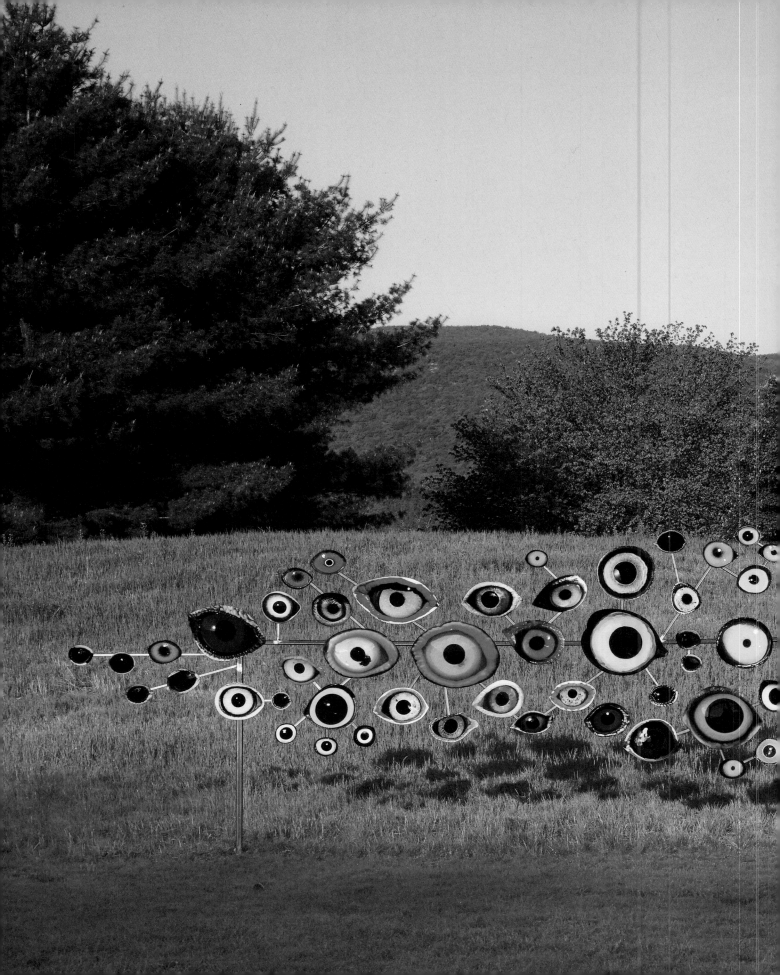

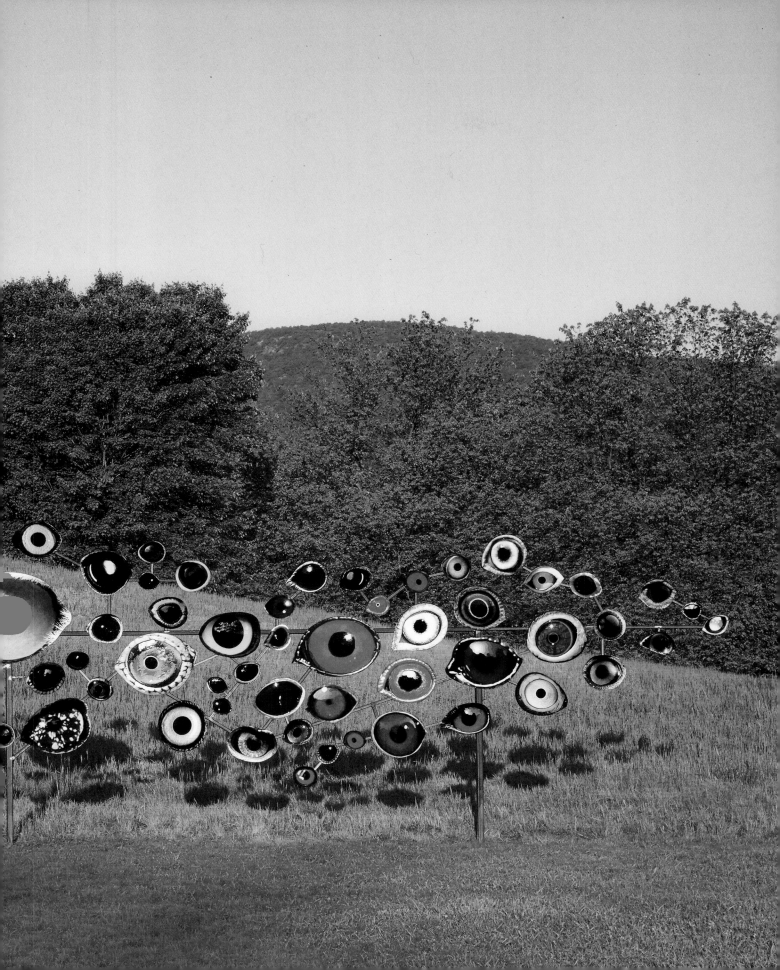

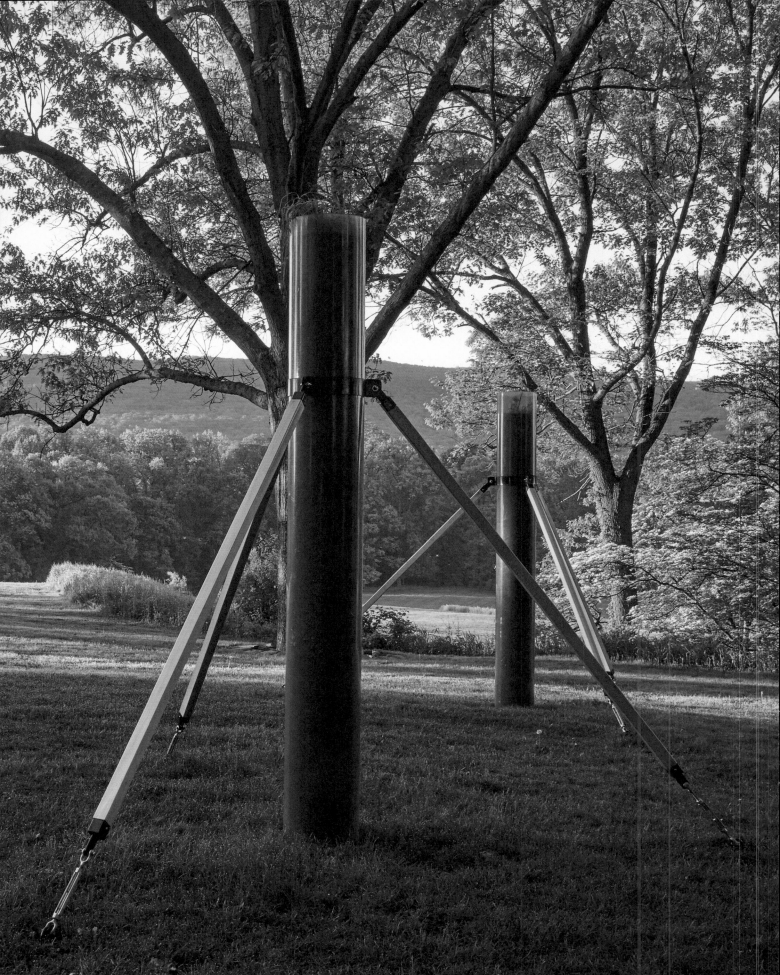

FOREWORD AND ACKNOWLEDGMENTS

John P. Stern
President, Storm King Art Center

Indicators: Artists on Climate Change features a wide range of creative installations by seventeen artists. The topic of this exhibition not only is aligned with the mission of Storm King Art Center today, but is also a reminder of a lesser-known part of our history of reclaiming and protecting land.

The late landscape architect William A. Rutherford Sr., who worked for forty-five years to create this landscape for large outdoor sculpture, described Storm King as first and foremost "an environmental project." Rutherford was referring to the vision of Storm King's founder, Ralph E. Ogden, and Founding Chair, H. Peter Stern: to acquire and reclaim land adjacent to Storm King's Museum Hill, which had been devastated by the construction in the 1950s of the New York State Thruway. The massive gravel pits created for the Thruway had a significant impact on the environment; the disruption destroyed trees, plants, and habitats for wildlife. Over several decades, Rutherford used the leftover gravel to create and restore this landscape for sculpture.

During these same years, Ogden and Stern were working to preserve Storm King's viewsheds by acquiring open space in the Hudson Highlands. Ogden's signature purchase—twenty-one hundred acres on the east side of Schunnemunk Mountain—led to the creation of Schunnemunk Mountain State Park in 2000. Another example of Storm King's environmental stewardship was an ambitious project to seed and establish more than two dozen native grass fields at the Art Center over the past two decades. These grasses have enhanced our landscape with their changing palette, but they are also critical for our future. One of Maya Lin's works in this show, *The Secret Life of Grasses* (2018), demonstrates how these remarkable drought-resistant plants can both reduce carbon emissions and improve our soils.

Indicators: Artists on Climate Change is aligned with our mission in another more subtle, but no less significant, way. The experience of the exhibition compels the visitor to wander widely, to peer closely, to think deeply, and to observe the resonance between art and nature—which is the very essence of Storm King Art Center.

This exhibition is an incredible accomplishment in terms of the scope and quality of the works presented. Many people deserve recognition for their part in making this exhibition a reality. I am extremely grateful to Storm King's Board of Trustees for their support of this undertaking and their appreciation of the theme as one intrinsically tied to Storm King's mission. *Indicators: Artists on Climate Change* is made possible by generous lead support from Roberta and Steven Denning, Agnes Gund, the Hazen Polsky Foundation, the Ohnell Charitable Lead Trust, and the Samuel Freeman Charitable Trust. Support is also provided by Janet Inskeep Benton, the Laurance S. Rockefeller Fund, the Lipman Family Foundation, Mr. Tom Steyer and Ms. Kat Taylor, and Sandra Wijnberg and Hugh Freund. Support for the catalogue is provided by the Elizabeth Firestone Graham Foundation. Special thanks to the Natural Resources Defense Council (NRDC).

Support for exhibition-related programming is provided by generous lead support from the Mr. and Mrs. Raymond J. Horowitz Foundation for the Arts. Support is also provided by Agnes Gund, the Pierre and Tana Matisse Foundation, and the Sidney E. Frank Foundation. Special thanks to The Jayne and Leonard Abess Foundation. Artist talks are made possible by the New York State Council on the Arts with the support of Governor Andrew M. Cuomo and the New York State Legislature.

We are all deeply grateful to the exhibiting artists: David Brooks, Dear Climate (including Una Chaudhuri, Fritz Ertl, Oliver Kellhammer, and Marina Zurkow), Mark Dion, Ellie Ga, Justin Brice Guariglia, Allison Janae Hamilton, Jenny Kendler, Maya Lin, Mary Mattingly, Alan Michelson, Mike Nelson, Steve Rowell, Gabriela Salazar, Rebecca Smith, Tavares Strachan, Meg Webster, and Hara Woltz. We have benefited from their talents, intellect, and energy, and we continue to learn from each of them. The exhibition would not be possible without our generous lenders, including 303 Gallery, Tanya Bonakdar Gallery, Bureau, Paula Cooper Gallery, Liz and Jonathan Goldman, Matthew Gribbon, Robert Mann Gallery, and Pace Gallery.

Colleagues studying both climate change and visual art have shared with us their ideas as this exhibition came together, and representatives from artists' studios and galleries have also provided critical assistance. We would like to thank Sivan Amar, Erin Carroll, Brandy Carstens, Lucas Cooper, Ida Ellisgaard, Katy Erdman, James Cabot Ewart, Jake Ewert, Taraneh Fazeli, Jason Foumberg, Gabrielle Giattino, Beatrice Gross, David Hart, Ted Janilus, Candice Madey, Miranda Massie, Katita Miller, Larry Ossei-Mensah, Veronica Roberts, Cameron Russell, Alexandra Schwartz, Mariko Tanaka, Christoph Thompson, Erica Weiss, and Emily Wilkerson.

At Storm King, an innovative curatorial team consisting of David R. Collens, Director and Chief Curator; Nora R. Lawrence, Senior Curator; and Sarah Diver, Curatorial Assistant, shepherded this exhibition from start to finish, and collaborated with artists to help their ideas come to fruition. Mary Ann Carter, Executive Assistant to the Director and Chief Curator, capably handled exhibition

planning, organization, and shipping. Intern Maya Polsky gave of her time and research prowess. Mike Seaman, Storm King's Director of Facilities and Conservation Specialist, led a talented and dedicated crew that worked through the winter and into the spring, indoors and out, on the fabrication of eleven newly fabricated outdoor sculptures, in addition to the installation of the indoor galleries. These members of our facilities team, including Mike Cook, Robert Finch, Joel Longinott, Armando Ocampo, Florencio Ocampo, Mike Odynsky, and Howard Seaman, were deeply admired by all of the artists who worked with them for their talents and dedication.

Many other staff members contributed to this exhibition. Our curatorial team partnered extensively with our Education and Public Programs department, led by Victoria Lichtendorf and including Ellen S. Grenley, Hannah Walsh des Cognets, and Sara J. Winston. Our education interns and museum docents also provide critical help. Rachel L. Coker and the External Affairs staff worked tirelessly to fund the exhibition, organize related events, and, with outside counsel from FITZ & CO, strategize on marketing and communications. Anthony Davidowitz and his team provided legal, technical, and on-site assistance; Dwayne J. Jarvis adeptly managed the budget and finances for the exhibition; and Amy S. Weisser contributed to strategic thinking. Storm King's entire staff has assisted with the exhibition in myriad ways, and I am grateful for my extraordinary colleagues.

Our exhibition films were directed by Graham Mason, and this beautiful catalogue and the accompanying exhibition materials have been designed by Pascale Willi, with production management by Christina Grillo and editing by Libby Hruska.

INDICATORS: ARTISTS ON CLIMATE CHANGE

During the last week of installation for this exhibition, our Hudson Valley region, usually protected from the most extreme weather conditions by its surrounding mountains, experienced a tornado. Throughout the planning stages of the exhibition, among many other very visible environmental crises, wildfires ravaged areas of California and hurricanes displaced thousands of people and caused billions of dollars of damage in Florida, Puerto Rico, Texas, and other areas in the Caribbean. In early 2017 the *New York Times* hired a climate editor and ramped up its coverage of issues related to climate change, including adding a "Climate and Environment" section to its website. These are only a few examples of ways that climate change continues to affect our world in economic, cultural, scientific, and personal ways. Storm King Art Center's major exhibition for 2018, *Indicators: Artists on Climate Change*, uses Storm King's Museum Building and five-hundred-acre site as opportunities for seventeen contemporary artists to present work that engages with some of the many challenges that a changing climate has brought to humankind.

"To indicate" is to point out or demonstrate something; to suggest an appropriate course of action; to be a sign or symptom of something. In the context of this exhibition, the title *Indicators* draws comparisons among each of these definitions and the artists whose works elucidate, reflect on, and point to the urgency of addressing a climate in flux. In developing this exhibition, our curatorial team constantly learned about new predicted effects of climate change, both from the artists included here and from breaking news, which updates itself with more urgent statistics by the day. To use the word indicators demonstrates that climate change is a vast and unwieldy syndrome, with distinct symptoms and prognoses for the health of our planet and its life. Just as there is no one manifestation of climate change, the seventeen artists included here approach the myriad factors of this syndrome from their own unique perspectives.

The contributions of some artists to the exhibition directly engage scientific discovery. Mark Dion's outdoor work *The Field Station of the Melancholy Marine Biologist* allows viewers to enter

the workday of a marine biologist, whose daily collection, study, and interpretation of a natural world threatened by climate change may leave him or her with a sense of despair. Hara Woltz's *Vital Signs* is an interactive weather station consisting of nine cylindrical elements—which reference the ice cores used by paleoclimatologists to study climate history—that translate the disappearance of Arctic ice into a visceral experience. Both works allow viewers to step into the role of a climate scientist in order to understand the labor of collecting data about the natural world as well as the emotional toll of observing the disruption to the planet's ecosystems. David Brooks's *Permanent Field Observations* comprises thirty bronze castings of ephemeral natural objects found within Storm King's woods, including part of a deer skeleton, mushrooms, vines, and twigs. Brooks affixed these bronzes alongside the subjects from which they were cast, and asks visitors to enact their own scientific expedition as they search for them. As future weather patterns alter these sites in unknown ways, these intimate replicas will act as time capsules, presenting the woods as they are in 2018. Brooks's work, which is drawn from his own experiences engaging in various expeditions, humanizes the scientific process: visitors likely will not find all of the bronzes, just as a scientist may not be able to locate an endangered frog, an absence that could mean either extinction or an unlucky day of searching.

While scientists continue to grapple with measuring and modeling Earth's rapidly shifting climate, many regions are routinely feeling the effects of climate change with the increasing occurrence of extreme weather patterns. Artists Allison Janae Hamilton and Gabriela Salazar highlight the social and cultural impact of climate-related disasters, speaking to the ways in which communities disproportionally affected by these storms can come together. Hamilton's monumental stack of tambourines, *The peo-ple cried mer-cy in the storm*, is titled after lyrics from the song "Florida Storm," a hymn written in 1928 in response to the Great Miami Hurricane of 1926. Hamilton connects this and other historical storms to those of the present-day South, where many predominantly black communities live in low-lying, coastal areas, vulnerable to flooding from rising sea levels and ever more powerful storms. Hamilton's work makes a case for cultural production as a force for community resilience and strength in the face of natural disaster. Echoing in material and form the temporary shelters built during disaster relief efforts, Salazar's *Matters in Shelter (and Place, Puerto Rico)* responds to the widespread devastation of Puerto Rico by Hurricane Maria in September 2017 in a manner that invites individual contemplation.

Climate change can cast a pall over routine aspects of human life, and can color our interpretations of human tragedy. As an artist embedded on an Arctic-crossing ship collecting climate data, the *Tara*, Ellie Ga charted the frustrations, hopes, daily tasks, and physical traces of the scientists aboard the ship to make her installation *The Fortunetellers*, part of an ongoing series. Mike Nelson's work

Eighty circles through Canada (the last possessions of an Orcadian mountain man) is a deeply personal rumination on the ways humans make their mark on the landscape, juxtaposing the loss of the natural world with the intimate grief associated with the death of a friend.

Several artists included here find hope in reconsidering agricultural and planting practices for a warming climate. Maya Lin's outdoor work *The Secret Life of Grasses* includes three ten-foot-tall clear tubes, each housing a single stalk of prairie grass and making the grasses' entire structure—from root to tip—visible. The tubes demonstrate the extensive root systems of the types of grasses that have been reintroduced into Storm King's landscape over the past twenty years, while also pointing to prairie grasses—with their ability to sequester great amounts of carbon from the atmosphere—as a possible solution to mitigate a primary cause of climate change. In contrast, Mary Mattingly imagines the Hudson Valley as a hub for growing tropical fruit in a warmer future. To create *Along the Lines of Displacement: A Tropical Food Forest*, the artist transplanted tropical fruit trees from Florida to Storm King and installed them as a living sculpture. The work is a proposal for a future that is predicted by the turn of the next century, when a temperature rise of 4 degrees Celsius (7.2 degrees Fahrenheit) is projected to be the baseline in many places around the world. Offering a model for today's agricultural industry, Meg Webster's *Growing Under Solar Panels* showcases bee-friendly plants and wildflowers.

Other artists consider and question the most insidious aspects of environmental and societal destruction. Steve Rowell's film *Midstream at Twilight* traces pipelines, barges, and other transit pathways of petcoke, a particularly destructive form of petroleum—the production of which has long been kept in the shadows. Rebecca Smith envisions her work *Maquette for Weather Watch* as a depiction of a postapocalyptic landscape brought on by climate change.

The collective Dear Climate, Justin Brice Guariglia, and Tavares Strachan all created text-based works to address audiences directly. Dear Climate encourages viewers to undergo a three-part process of meeting the climate, befriending the climate, and becoming the climate, an intention demonstrated through their rhythmic and ceremonial procession of flags, *General Assembly*. Guariglia's *We Are the Asteroid* employs a highway message sign—bearing messages such as DANGER: ANTHROPOCENTRISM and EFFICIENCY IS PETROSPEAK—to bring attention to how humans have allowed for unsustainable systems that contribute to climate change. Across three works, Strachan interrogates the narratives, histories, and myths surrounding the Arctic, as well as that region's vulnerability to today's changing climate—notions captured simply in a neon sign that declares *Sometimes Lies Are Prettier*.

Jenny Kendler and Alan Michelson focus on locally endangered species, calling out humans' failure to protect natural ecosystems as a prime contributor to rising temperatures. Kendler's outdoor

sculpture *Birds Watching* takes on the appearance of a "flock" of one hundred colorful, reflective birds' eyes, each of which depicts a bird species considered threatened or endangered by climate change, creating a portrait of what may disappear in fifty years' time, according to a recent study by the Audubon Society. For his video *Wolf Nation*, Michelson has transformed found footage of red wolves, a critically endangered species indigenous to the Northeast, into a vibrant meditation. In it, the artist links the eradication of the wolves with that of the Munsees, the Lenape people known as the Wolf Tribe, whose ancestral territory includes the land where Storm King Art Center is located. In considering fellow nonhuman beings in and around Storm King, Kendler and Michelson ask viewers to contemplate their own role in caring for these species' home.

Indicators is structured to be particularly artist-forward in its approach. We worked closely with all seventeen of the artists here; eleven of them created new works for this show. For this volume, we have chosen to foreground the artists' voices, and nearly all of the texts that follow consist of either excerpts of interviews or statements by the artists. The works included here reveal how acts of making and viewing art can enlighten, inspire change, and provide opportunities for personal reflection—even collective mourning—in ways that differ from research, advocacy, and reportage. The artists in this exhibition have drawn inspiration from Storm King's landscape, mission, and local ecosystem to speak to broader issues of the environment, global climate trends, and human ways of life. Storm King's site provides a unique platform from which to address these issues—a setting that can provide specific connections to our region, or speak metaphorically about natural systems everywhere. In this context, Storm King's outdoor exhibition space adds even more immediacy to this already urgent topic: as audiences are prompted to contemplate the fragile state of our climate, the majestic beauty of Storm King's landscape and surrounding nature stands as a reminder of what is at stake.

David R. Collens, Director and Chief Curator
Nora R. Lawrence, Senior Curator
Sarah Diver, Curatorial Assistant

PLATES

DAVID BROOKS

For *Permanent Field Observations*, thirty various-sized bronze castings have been permanently affixed in the wooded areas surrounding Storm King's five-hundred-acre site. Myriad ephemeral sculptural situations were sought out, particular settings I found compelling (veritable readymades!) among the minutiae of this wooded perimeter. These readymade sculptural situations included such subtle and prosaic things as tree roots clutching rocks, a casual overlay of sticks fallen atop each other from adjacent trees, mushrooms growing off decomposing branches, sapling trees snapped in half but still intact, the remains of a deer skeleton, twisted vines, coyote scat, fractured rocks, and many combinations of these. Rubber molds were carefully prepared and executed precisely where the situations were found, so as not to disturb the ephemeral makeups. Wax positives were then made to be cast in bronze, as well as to have a display copy on view in the Museum Building—to give viewers an impression of what awaits in the wooded perimeter for the close observer.

The final bronze duplicates were installed directly next to their respective ephemeral situations from which they were cast, where they now remain affixed in place, permanently, forever. These intimate and unmonumental moments of sticks, stones, trees, earth, and other found elements will live side-by-side with their fossilized selves. The bronze replicas will act as time capsules as they outlive us, and, as future weather patterns alter the site in unknown ways, they'll even outlive today's climate moment. In support of this gesture, Storm King and I have made an agreement that the bronze casts are to remain in their anchored locations eternally—juxtaposing these subtle, fragile, naturally occurring but ephemeral moments with something much larger than ourselves. By engaging these unmanicured wooded areas, I am asking viewers to reconcile the intimate moment of apprehending the sculptural object in a quiet moment in the woods with the vastness of the sculpture's potential lifespan of thousands of years. Such a reconciliation of disparate perceptions is not too dissimilar to how one might introspectively experience the conflicted notion and existence of climate change.

A map on view in the Museum Building plots the precise locations of these fossilized field observations, complete with their longitude and latitude coordinates. Similar to scientific expeditions working to account for the many species becoming extinct due to human impact, viewers of *Permanent Field Observations* must recalibrate their perceptions to infinitesimal details within the context of this imminent global change.

— *Statement by the artist*

Permanent Field Observations, 2018
Bronze
Dimensions variable
Courtesy the artist

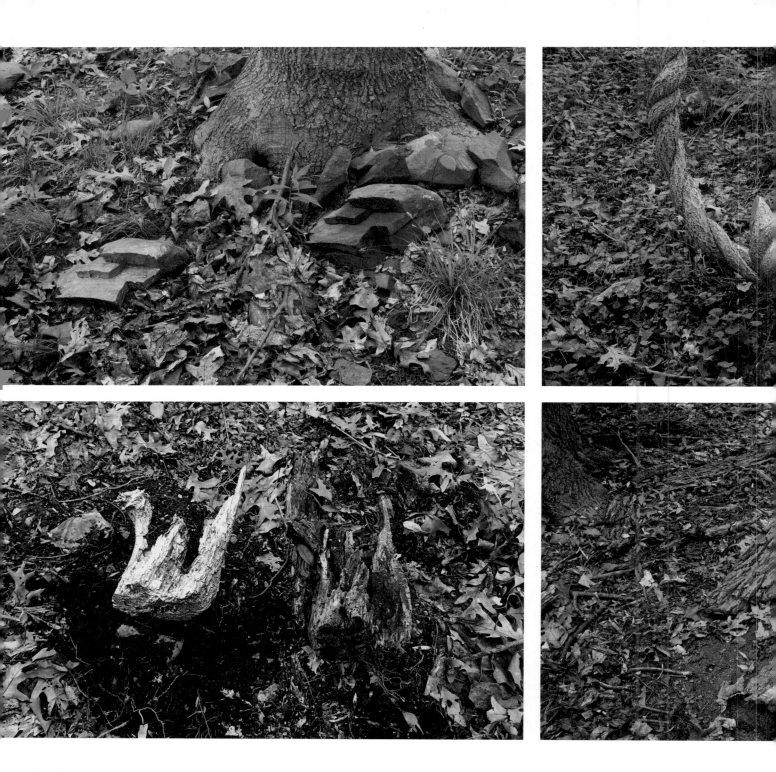

Permanent Field Observations, 2018
Bronze
Dimensions variable
Courtesy the artist

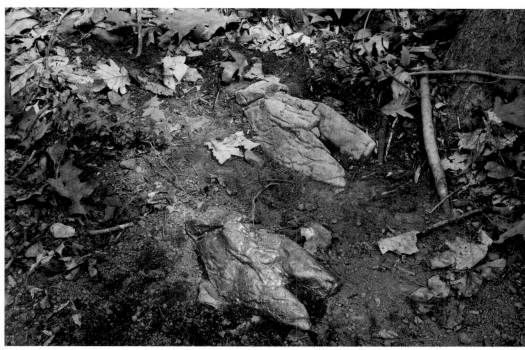

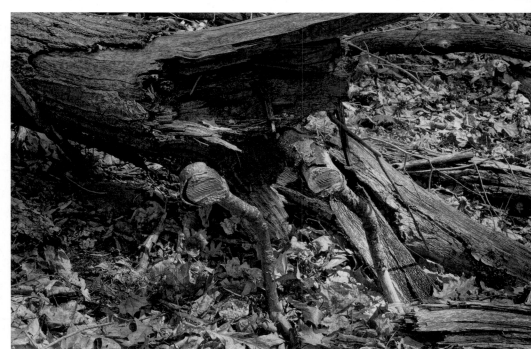

DEAR CLIMATE (U CHAUDHURI, F ERTL, O KELLHAMMER, M ZURKOW)

General Assembly began with an open invitation to consider any part—or parts—of Storm King for a manifestation of our ongoing project, *Dear Climate*. We made two site visits to see how we could put this project into conversation with this extraordinary place, and immediately we could see all kinds of opportunities: from very intimate interactions with the elements of "nature" that are such a defining feature of this place, to more public and ceremonial effects emerging from the majestic vistas and stirring landscapes here.

We gradually whittled down our plan to create something that combined an inward experience with a very outward-facing feel, using a style of greeting and welcoming to invite attention to the "more than human" world. This plan was focused on the circle where the tram drops off and picks up visitors, which had from the start seemed to us to be very ceremonial, very formal, compared to other more intimate spaces of Storm King. We decided to use this lovely circle to create a utopian space that heralds change by welcoming all species.

In considering the kind of imagery we wanted to feature (drawing from our posters but turning them into flags) we got interested in having the piece—the circle of flags—also have a *rhetorical* structure. Besides the general effect of welcoming you, the flags now also want to take you on a small—quiet, inward—journey, as you move around the circle. All the black flags were created for this particular work, and they posit current problems to which the sections of white flags are responses. In addition, the white flags are divided into four groups—plant-based, animal-based, climate-based, and grief-and-acceptance based—suggesting various domains of response to the concerns that the black flags spell out.

This call-and-response structure emerged very organically. The fact that it was a circle, as well as place of arrival, all set within a dramatic landscape that decenters the human, turns attention to the larger world we share with other species. All this gave rise to the idea of new rituals of inclusion, new calls and responses beyond the human, and new institutional structures—complete with flags!—to honor them.

Dear Climate is an ongoing modular project that we've been working on for four years. Site-specific exhibitions give us ways to test our ideas in particular contexts, to make new discoveries, and then to add to the repository that *Dear Climate* is: a library of material that people can download, do workshops with, and so on. We think of the presentations themselves as opportunities to go deeper into the questions with which we began this project, and which have changed over time.

When *Dear Climate* first began, we were more focused on the idea of changing individual feelings and imaginations about the nonhuman world. One of our slogans was: "Retool your inner climate." As the title of our project (and the collective itself) implies, we wanted to cultivate a sense of affection for the climate and offer a platform from which to address the climate—to give it personhood. In the manifestation at Storm King, that individual imagination is being challenged to become more sociological, even more political (since flags are often associated with nations and

causes). The site we selected has made *Dear Climate* move further into the realm of public address than it has ever done before.

This is also a response to some thinking about what felt like "problematic" aspects of Storm King itself, especially the ease with which it can become a kind of *retreat* from our "real" lives into (what we call) "capital N Nature," a rarefied, gardenlike, tamed, managed, manicured, cultivated experience of nature that people use to "get away." The reason that is problematic is because it tends to reinscribe a division between nature and human activities, between the nonhuman world and the human world, which is dangerous to the health of the planet and all the species on it. This habit of thinking of nature and culture as opposites, just like the habit of thinking that humans and animals are opposites, allows us to forget that we are *Earthlings*, one species *among many* that share this planet. *Dear Climate* is dedicated to helping us remember that we humans are *always* part of the Earth, of "nature," and we are so *all the time*, not just when we go to the park or into the wilderness.

Thinking of humans as a species, and one that is deeply entangled with all the other species that inhabit our planet, and also entrenched within the bio-geo-physical systems (including climate) that govern the Earth: that's quite a long way from the original question *Dear Climate* began with, which took issue with the idea of "survival." Our initial question was: What are tools of survival that we need, that are mental rather than physical, that are not the typical "survivalist" skills that are touted and imparted in climate change apocalypticism?

A first answer that emerged resisted relating to the climate as a *problem*. Instead, we imagined three stages of thinking-feeling, which we named "meet the climate, befriend the climate, become the climate." Our posters at that stage imagined ways to extend human modes of sociality—such as friendship, flirtation, creativity—to the nonhuman world. More recently, we have been moving beyond gestures of openness, affection, and friendship to the nonhuman world and adding a commitment to developing a new knowledge, to living with a new paradigm, a multispecies ontology that sees humans as completely traversed by other forces and species. Now our questions are: Can you give up some of your separateness? Can you give up some of your objectness? Can you merge with other forms and other beings? Can you have less distinct edges?

We hope this manifestation of *Dear Climate* will create openings for new relationships to the climate and to the nonhuman world in general. The black flags raise more familiar kinds of political questions—about climate denial, the huge gap between the rich and the poor, environmental injustices, planetary health. And we're hoping that the white flags respond to those questions not in a mode of scarcity and reduction, but of pleasure, expansiveness, inclusion.

We want to create a public space that signals—and celebrates—a future world of multispecies collaboration. At the UN General Assembly, there's a seat for every nation. In our General Assembly of the future, there'll be a seat at the table for all species and all things.

— Excerpt from an interview with Storm King Art Center

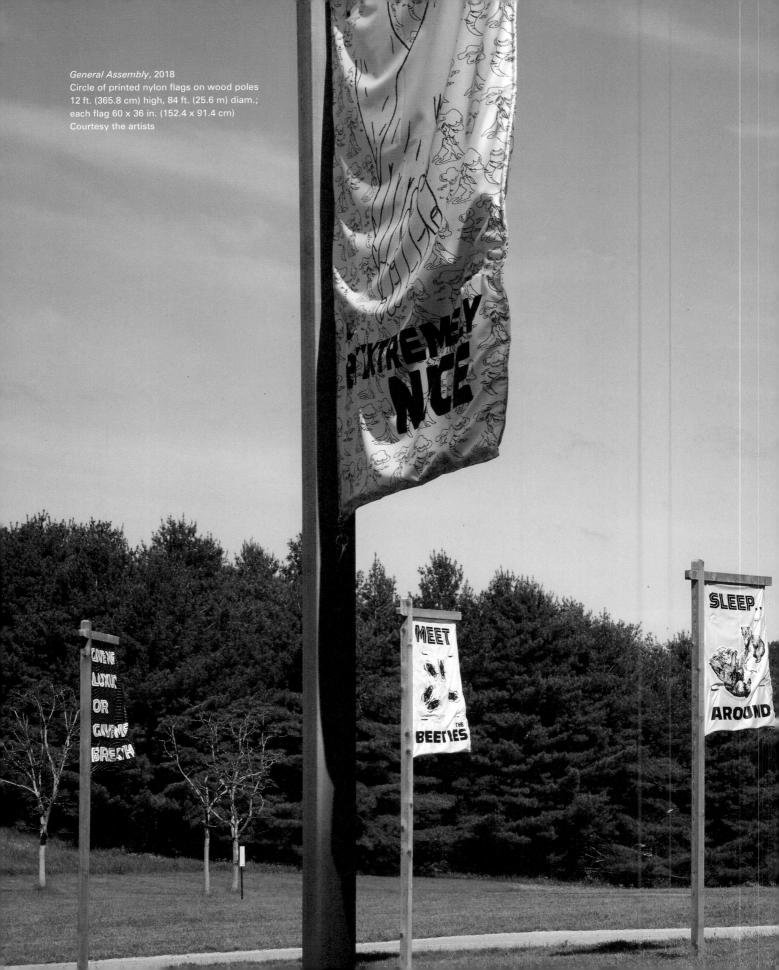

General Assembly, 2018
Circle of printed nylon flags on wood poles
12 ft. (365.8 cm) high, 84 ft. (25.6 m) diam.;
each flag 60 x 36 in. (152.4 x 91.4 cm)
Courtesy the artists

MARK DION

The Field Station of the Melancholy Marine Biologist is a large-scale sculptural work in the form of a vernacular building in the landscape. The public views the work by peering through the building's ample windows. Inside they see a lab, modeled on biological field stations and Doc's laboratory from John Steinbeck's novel *Cannery Row*. Doc, the main character of this story, is a collector of specimens for biological supply companies, aquariums, and professionals in marine biology. When viewers look inside, the space seems like a laboratory for a marine biologist, complete with the equipment, apparatuses, books, and materials that you might find in a field station. Doc's space is described as almost an alchemist's laboratory of biodiversity: a celebration of the weird and wonderful life of the Pacific Ocean. *The Field Station of the Melancholy Marine Biologist* is not so much a celebration of biodiversity, but a space for mourning its loss.

The space I've created feels not quite of this moment, so dominated by the digital and virtual. But equally it is not a period piece from the days of William Beebe in the early twentieth century. There is too much plasticware and contemporary material to be nostalgic. The work embodies a different kind of moment—one in which someone studying the natural world realizes that the future is not looking so good. For those interested in marine biology, ocean health, biodiversity, and coral reefs, there is very little good news out there.

Anyone studying marine diversity today must feel overwhelmed and deeply demoralized. Generally people don't study these things because they're disinterested. They study things because at the core of their heart there's a love and identification. However, it would be very hard to study ocean life and not come to the catastrophic conclusion that we are going to lose a great amount of the natural wonders that have been here in previous centuries.

The space isn't meant to feel abandoned. I want it to feel more like the viewer just missed the occupant because they went out for a coffee or a beer. There's a kind of mystery as to where that character is and whether he or she will return at any moment. The viewer should feel a bit uncomfortable with the voyeuristic role they have been forced to play.

The piece was originally made for Prospect New Orleans. Because of the Deep Water Horizon oil spill in 2010, and the subsequent spreading of dead zones created by the release of enormous amounts of nutrients through the Mississippi drainage basin, New Orleans is kind of ground zero for habitat loss and threat to the plants and animals that live in the ocean community. The Gulf of Mexico and the Mississippi basin are sites of enormous environmental catastrophe unfolding in slow motion.

In terms of siting the piece here at Storm King, the problems in the Gulf of Mexico are not entirely unlike the problems of the North Atlantic region of the United States. We have some of the same issues in relation to poor management of fisheries, the desire to exploit petroleum resources, and habitat loss.

I come from New Bedford/Fairhaven, Massachusetts, which has both success stories with the fisheries—for instance, the wise management of the scallop fishery industry—but also disastrous examples of mismanagement, greed, and illegality, which have fomented tensions between scientists and fishermen. These tensions are hard to resolve and have resulted in animosity on both sides, and it seems virtually impossible to imagine these two cultures ever finding a productive way of working together. Even though those tensions could be a great opportunity to chart a new productive future for the seas, I just can't imagine it happening. The challenge that New Orleans faces with ocean plastics, pollution, and other factors that impact marine health are very present here as well. We have the same issues of coastal communities relying very much on clean beaches and healthy oceans in order to be economically viable and desirable as sites.

At Storm King, there was an opportunity for me to include some materials that make the piece a little more personal—and maybe even biographical—in relation to where I come from and the organisms that I've seen decline within my lifetime. A lot of my work on these kinds of issues is motivated by a love of the natural world based on my personal experiences as a kid growing up in Massachusetts and spending enormous amounts of time in wild places with wild things, and seeing some of those things decline and change dramatically.

The Field Station is a bit of an architectural folly. Follies—diminutive buildings that are meant to generate meaning rather than have a practical function—open up possibilities in imagining how to work in public space and in public art, in a materially complex manner that addresses social and cultural concerns. They are an exciting model for public art because one gets to work in something that is architectural in scale and has an architectural presence but remains sculptural. It's a way to turn a building into a sculpture, and also into a vitrine. At the same time I don't have to give up being an artist who works with a lot of material culture in the form of an installation.

I've done a variety of works going back to the mid-1990s using this model of creating a building that can also be a sculpture, that can also be an installation, which sometimes includes people entering that space and sometimes excludes people from that space. So this concept and method is something that's very much in my artistic domain and vernacular. Even though this work is a building, the public doesn't enter inside. Viewers experience the work by looking through the windows. There is this construction of desire in the audience. Although it is made in a way that you can pretty much see everything that's there, viewers always feel as though they could be missing something.

— *Excerpt from an interview with Storm King Art Center*

The Field Station of the Melancholy Marine Biologist, 2017–18
Mixed-media installation
16 ft. 2 ¾ in. x 24 ft. 1 ½ in. x 9 ft. (494.7 x 735.3 x 274.3 cm)
Courtesy the artist and Tanya Bonakdar Gallery, New York

ELLIE GA

The Fortunetellers is based on the five months I spent drifting with the scientific expedition on the *Tara*. The *Tara* is a two-masted sailboat, which was stuck drifting in the ice for a year and a half. There were ten of us aboard. I was the one artist but I was also part of the crew.

I quickly realized that I needed to make artwork for my crewmates. And through that, I developed work for the lecture series we had on the *Tara*. The works were about our situation. We were drifting—indefinitely, to some degree—with the Arctic pack ice, never knowing when we would get back home. Yet we were there to help predict the future of the Arctic region by measuring the pack ice. This contrast between trying to help predict the future and being so anxious about our own future led to me calling the entire series of works *The Fortunetellers*.

One of the scientists aboard explained to me that the more you can eliminate human bias, the more valuable data is. But can human bias be eliminated? I think of *The Fortunetellers* as a reflection of our psychological state while we were collecting this data that ostensibly contained little human bias. For *At the Beginning North Was Here*, I asked my crewmates to draw me maps of how they saw the ice around us. There were all these names for parts of the ice—"OK, we're going to Copenhagen today. We're going to Saint Petersburg." Places were named to designate where the scientific instruments were. I also realized that my crewmates had private names for things that had resonance for them. So I asked everyone to draw me a map. People approached it in different ways. I recorded them talking as they were drawing their maps.

The Cast (502 Days) is a small piece that represents a way of measuring time, like a calendar. To get off the boat, there was a rod that scraped up against the doorjamb—it was so hard to open and close. These little details that comprised our everyday life: we couldn't get out the door half the time. Over the year and a half of the expedition, that gesture made a very intense indent on the doorjamb. I told the doctor of the expedition about how much I loved this indent as an indication of time passing. She was inspired by my observation and sacrificed most of our plaster of Paris bandages so I could take an impression of the doorframe. When I got back to New York, I brought it to a foundry and we used that to make the mold for *The Cast*.

After the expedition, I was trying to write a performance. I had taken hundreds of photographs, but I was attracted to the same ones. I felt like I was starting to remember the expedition in a predictable pattern. So I gave a friend my hard drive, and I said, "Can you pick just fifty-two photographs?" I cut them down into cards. I would deal out combinations of these cards, talking into a recorder, saying whatever came to mind. Different combinations of images triggered different memories, and from that I made the script for *The Fortunetellers*. Then I took this deck that I was using and editioned it. I gave every card a name and a symbol. For example, *Crystal Ball* represents the news. *Amulet* represents safety at sea. The one card that was always the same is *The Sun*, and that's the center card. *The Sun* card is fixed and then the other cards are dealt out and no reading is the same twice. *The Deck of Tara* is a play on words: the deck of cards, the deck of the boat.

There was this ongoing joke about all the shoveling we did—the absurdity of shoveling the Arctic. We had to keep the *Tara* free of snow to prevent sinking. That was one of our main jobs. We would plant our shovels outside the boat and then we would go from station to station shoveling while doing stop-frame photography. The photograph *Remainder* is from those reenactments. It is one of the few photographs I was able to take with my Rolleiflex camera before the sun set for the winter.

Map of the World has a direct reference to *At the Beginning North Was Here*—it is my map of our world. I kept updating it over time. Things would get moved over: say there was an ice break on the southeast side of the *Tara*, where the seismometer was, in an area we called Helsinki. We then would move the seismometer to a safer spot and then that would become New Helsinki.

This is the first time that works from *The Fortunetellers* have been shown as part of an exhibition related to climate change. I am glad that my works are reunited with the original context of the expedition: to study the effects of global warming on the pack ice. Naturally, we weren't always thinking about climate change during the expedition. We were mostly thinking, "How are we going to get this done?"

As we drifted through the ice we could never go back to the exact spot where we stood before. There's a sadness in this inability to go back, to retrace one's path. It's not just an existential feeling of having been a part of this unique expedition. It's also the idea that we might never go back to the pack ice regardless—that it is disappearing. I'm glad that I kept documenting our lives back then because now only the art remains. The memories are fading and the region is fading as well.

— *Excerpt from an interview with Storm King Art Center*

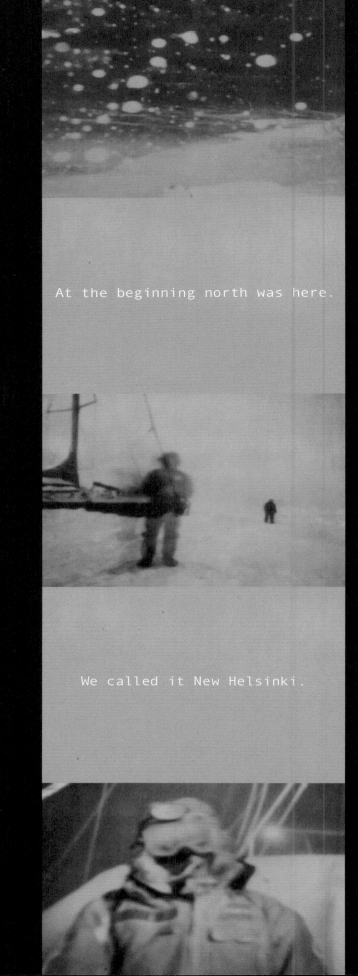

At the beginning north was here.

We called it New Helsinki.

At the Beginning North Was Here, 2009
Digital video and stop-frame photography (color, sound)
7:18 min.
Edition: 5, plus 1 artist's proof
Courtesy the artist and Bureau, New York

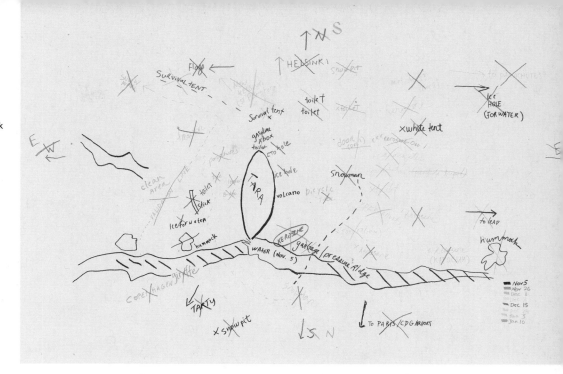

Map of the World, 2007
Marker on wall
Dimensions variable
Edition: unique
Courtesy the artist and Bureau, New York

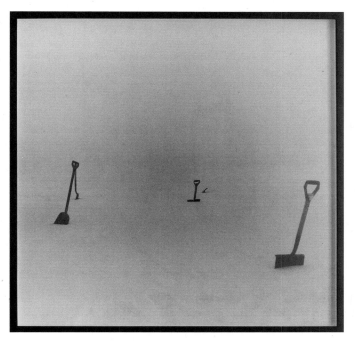

The Cast (502 Days), 2011
Cast white brass
9 x 1 ¾ x ½ in. (22.9 x 4.4 x 1.3 cm)
Edition: 3, plus 1 artist's proof
Matthew Gribbon

Remainder, 2010
Gelatin silver print
17 x 17 in. (43.2 x 43.2 cm)
Edition: 10, plus 2 artist's proofs
Courtesy the artist and Bureau, New York

The Deck of Tara, 2011
Fifty-two unique playing cards and booklet in wooden box
Box: 1 ½ x 4 ½ x 3 ¼ in. (3.8 x 11.4 x 8.3 cm);
installation dimensions variable
Edition: 10, plus 2 artist's proofs
Courtesy the artist and Bureau, New York

JUSTIN BRICE GUARIGLIA

Justin Brice Guariglia's practice reveals the problematic relationship humankind has with the natural world by visually and materially engaging with the landscape. For his site-specific work *We Are the Asteroid*, the artist presents a solar-powered highway sign, gilded in 23.75-karat rosenoble gold, flashing the following aphorisms in bright orange LED letters:

DANGER: ANTHROPOCENTRISM	WE ARE THE ASTEROID	THERE IS NO AWAY
EFFICIENCY IS PETROSPEAK	NEANDERTHALS 'R' US	HUMAN KINDNESS
WARNING: HURRICANE HUMAN	FOR SYMBIOSIS: REDUCE SPEED NOW	

The tongue-in-cheek phrases, collected and/or written by eco-critic Timothy Morton, spell out a warning, reminding the viewer they are complicit in the larger social and economic systems that contribute to changing the earth's climate—in other words, "we," or all human beings, are part of a planetwide, asteroid-like impact ensuring our own demise. As Guariglia has stated, "Humans are intertwined in multiple operating systems (i.e., the solar system, the animal kingdom, your local school district, etc.), but the system with the greatest impact on civilization today is the neoliberal agrilogistical system (how we produce things, how we move things around the planet, how we interact with the natural world around us). This system began with the advent of farming at the end of the last ice age, but recently it has begun to collapse upon itself because the current geopolitical structure, the nation-state, has been unable to provide the checks and balances needed to maintain the 'global commons'* we all depend on. The fallout from this is the ecological crisis, which has become the moral imperative of our time." Positioned outdoors in the rolling fields at Storm King, Guariglia's sign aptly proposes that human-centered ways of thinking degrade ecosystems and further climate change.

Guariglia also has a practice rooted in photography. As an embedded artist working alongside NASA glaciologists and scientists in Greenland, Guariglia photographed ice sheets from an aerial perspective while aboard a plane collecting data on global warming. The artist's interest in visually documenting human impact in the landscape prompted him to begin photographing mining and agricultural operations from a similar vantage point. The artist elaborates, "From the air, you gain a perspective of scale that you could never even imagine from the ground level."

Guariglia reproduces these aerial photographs in materials that speak to their origin—gold, copper, silver, aluminum—then manipulates the surface of each panel by hand. The artist has described his process: "After editing thousands of images, I would select a compelling frame that embodies a thought or feeling I have, then using a UV acrylic printer I print the image onto the surface of the substrate, let it sit for a few months to fully cure. Then I use a high-powered rotary sander to alter the surface, sanding down the acrylic, in some places all the way down to the support, in a way that mimics the human impacts on the land that is depicted in the image." The result is a large-scale abstracted portrait of human impact on the earth's surface made both visual and material.

* "Global commons" refers to the things all living beings on the planet share and depend on, like the air we breathe, the water we drink, and the habitable land upon which we live.

— *S. D.*

Mining Landscape (No.130/Au), 2018
24K gold leaf, acrylic, gesso, linen, and aluminum panel
40 x 30 in. (101.6 x 76.2 cm)
Courtesy the artist

Agricultural Landscape (No.133/Ag), 2018
Silver, acrylic, epoxy, and aluminum panel
40 x 30 in. (101.6 x 76.2 cm)
Courtesy the artist

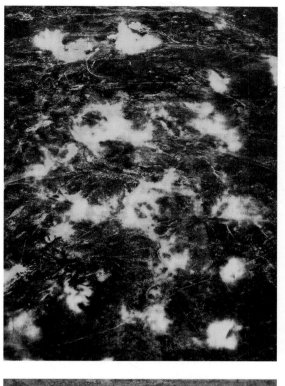

Mining Landscape (No.132/Cu), 2018
Copper, acrylic, epoxy, and aluminum panel
40 x 30 in. (101.6 x 76.2 cm)
Courtesy the artist

Agricultural Landscape (No.131/Au), 2018
22K gold leaf, acrylic, gesso, linen, and aluminum panel
40 x 30 in. (101.6 x 76.2 cm)
Courtesy the artist

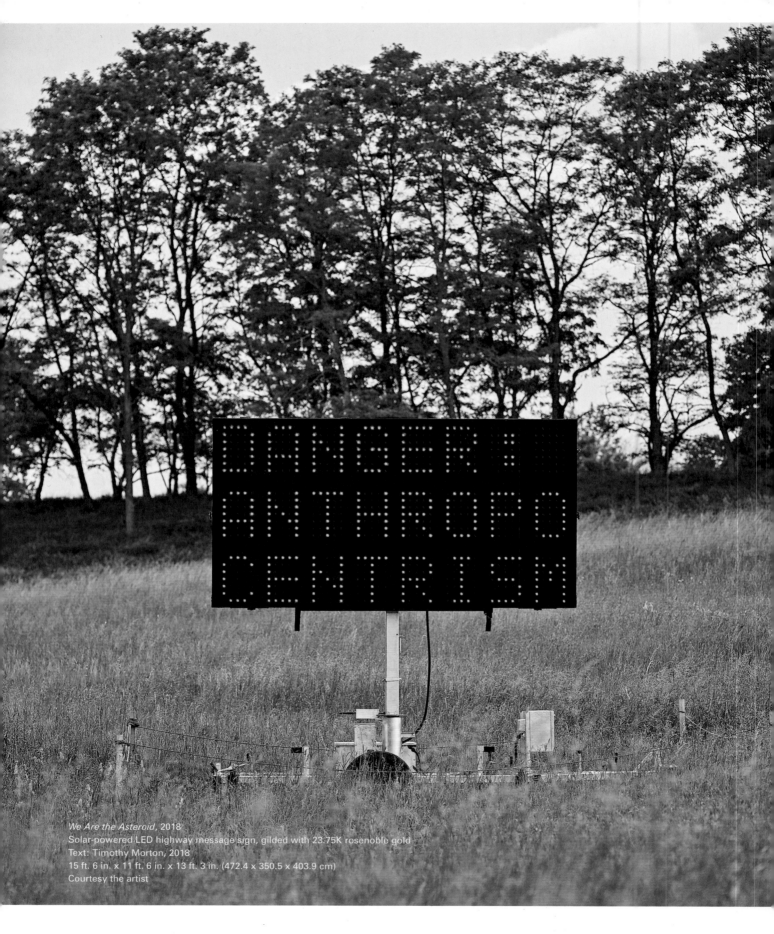

We Are the Asteroid, 2018
Solar-powered LED highway message sign, gilded with 23.75K rosenoble gold
Text: Timothy Morton, 2018
15 ft. 6 in. x 11 ft. 6 in. x 13 ft. 3 in. (472.4 x 350.5 x 403.9 cm)
Courtesy the artist

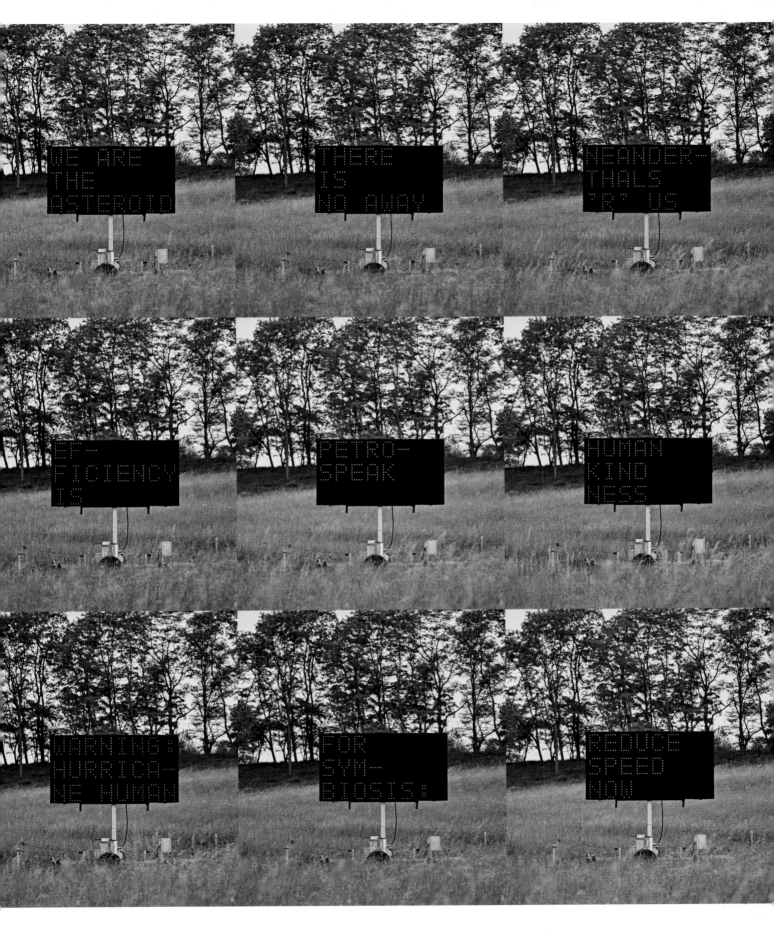

ALLISON JANAE HAMILTON

The peo-ple cried mer-cy in the storm consists of three stacks of white tambourines. The title is a lyric from a song called "Florida Storm," which was written by Judge Jackson two years after the 1926 Great Miami Hurricane, and right before the Okeechobee Hurricane in 1928. Jackson was part of a community of African-American sacred harp shape-note singers along the Florida and Alabama coast.

The more I started to listen to that song—with its beautiful yet haunting harp-like vocal projections—the more I felt the residents of that community trying to make sense of what had happened. It was only two years after the devastating storm in Miami. Then, that same year, another storm would come through the state again, this time in central Florida. It completely devastated farmland and killed thousands of black migrant workers. In the aftermath of that particular hurricane, there was no reverence for the life, work, and labor that had taken place in that region, and many of the migrant workers were buried in mass unmarked graves. The Okeechobee Hurricane was also the backdrop for Zora Neale Hurston's novel *Their Eyes Were Watching God*.

I was thinking of both of these storms and people's responses to them through song, through literature, and through other means. I also thought about other hurricanes, like the Galveston Hurricane of 1900, and, more recently, Hurricane Maria, which ravaged much of Puerto Rico. In thinking through this project, I was interested in how communities grapple with the aftereffects of natural disasters and how they become social disasters, illuminating already existing social disparities in any given location.

As someone who's from Florida and who comes from a family of farmers, it was really important to me to think through these stories and about how climate is an integral part of our lives, especially in communities that are not at the forefront of climate discussions, like rural families, poor families, and rural black farmers. I always heard my grandmother, aunts, and uncles discussing issues of environment and of climate. By middle school, I noticed these voices were not included in the overall climate discussion as it was presented in our school's curriculum or the media. I like to think that as artists, we have a unique role in that we are able to reflect upon what we're seeing and experiencing in the world, and render it in a way that makes sense to us and can resonate with the viewer.

I often deal with landscape in my work. Everything I do goes back to land and the earth, materials and matter, and how those things are part of our lives. Climate is part and parcel with that. It's important to address climate change in a way that demonstrates how it impacts communities that are not at the forefront of the conversation, yet are having these conversations in their own homes all the time because they're very directly impacted. Especially people who work in agriculture and other industries that are dependent on or beholden to what's happening with our natural environment.

"Florida Storm," for me, brings into the conversation these communities that have been talking about climate change, talking about environmental justice, and for whom all these issues have been pressing and important discussion points. Song is a literal way to bring voices in, and the tambourine—a symbol I use in my work as a stand-in for cultural production—reflects on social

circumstances, natural circumstances, and environmental circumstances at once. For me, thinking about climate change, it's about people, as well. It's about how the precarious, vulnerable environment we're living in is dealt with socially in ways that impact communities. From an environmental justice perspective, how do communities live with the land? How are things like oil spills, air pollution, or chemical pollution affecting communities today?

The peo-ple cried mer-cy in the storm is placed on an island in one of the ponds at the south end of Storm King. Because the sculpture sits in the middle of the water, viewers must position themselves around the tambourines from a distance. It's a contemplative moment, as the reflection of the tambourines is visible in the water. In terms of the viewer's position, they can feel, I hope, the immensity of the stack and the gravity of dealing with the aftermath of such a disaster.

As part of the exhibition, I'm also creating a performance titled *Epos: soundscape for thousands*, during which I will collaborate with musicians to reanimate Jackson's "Florida Storm" in abstract form. The musicians will repeat that line from the hymn over and over with different instruments. It will be a way to memorialize the aftermath of the aforementioned hurricanes—the social disasters elucidated by the natural disasters—through music and sound. The musicians will trade back and forth improvisationally, and, as viewers walk around the park and view the different sculptures, they will start to hear the music as they walk down toward the pond. As they get closer, they will, through this sonic experience, become immersed in the sculpture. Immersion is a quality I try to achieve in my work in one way or another. When you're working with something that is a tower, it's hard to physically immerse yourself. Sound is a way that I'm attempting immersion in this context. The performance will have both the feeling of a communal recitation and spontaneity—a sound bath of sorts.

— *Excerpt from an interview with Storm King Art Center*

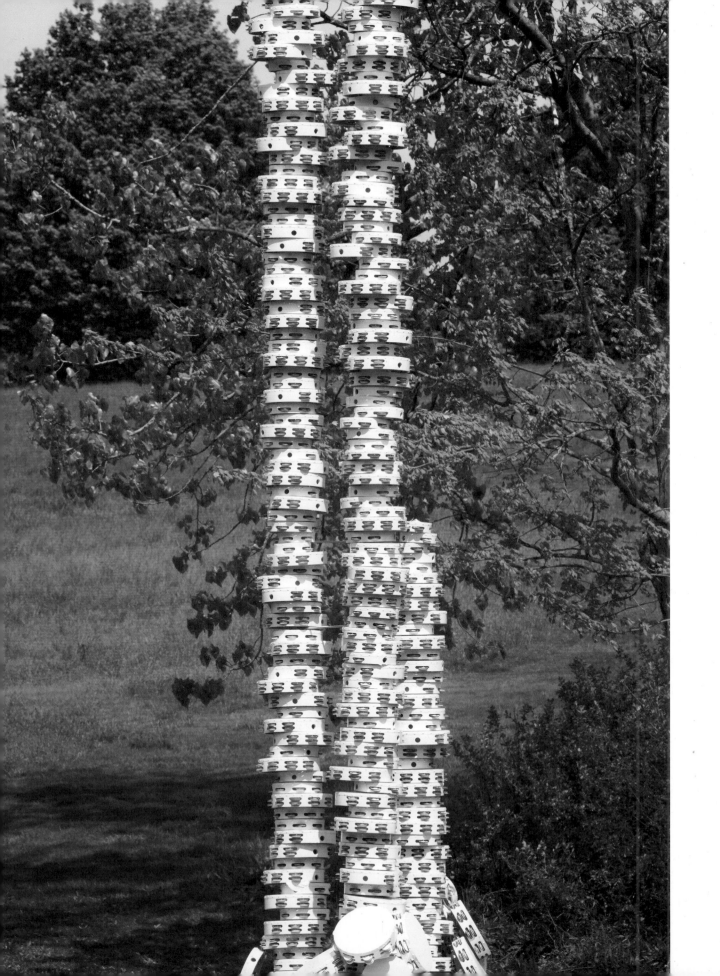

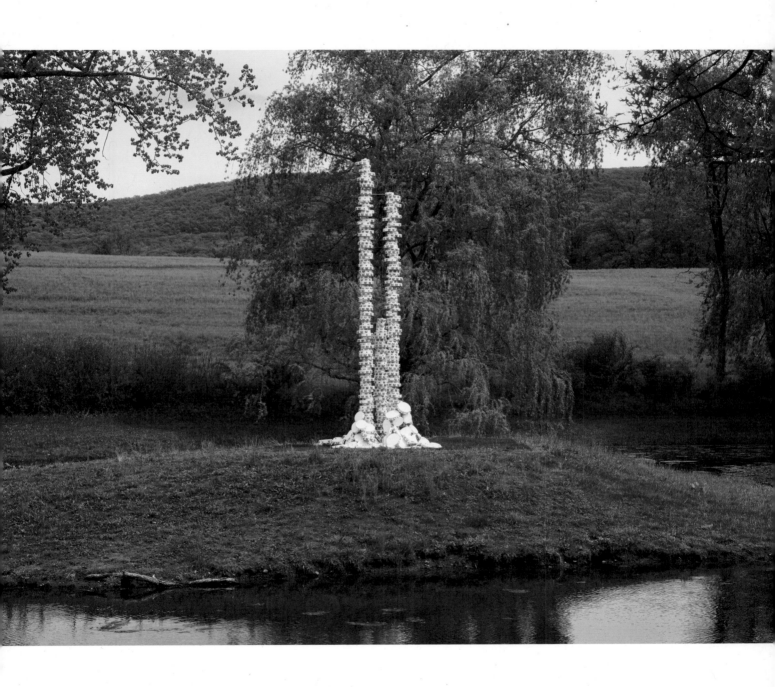

The peo-ple cried mer-cy in the storm, 2018
Tambourines and steel armature
18 ft. x 36 in. x 36 in. (548.6 x 91.4 x 91.4 cm)
Courtesy the artist

JENNY KENDLER

Birds Watching is composed of a "flock" of one hundred reflective birds' eyes mounted on aluminum. The luminous eyes wrap a hill of native grasses in a ten-foot-high band of color, "gazing back" when illuminated. Each eye belongs to a species of bird threatened or endangered by climate change in the United States—creating a potent portrait of what we stand to lose.

Within the gaze of these many others, the work asks us to consider our own responsibility for climate change's myriad effects on other beings. Have we allowed birds and other nonhumans—with their unique and wondrous lifeways—to become the sacrifice zones of extraction capitalism? As Surrealist André Breton suggested, in order to change ways of being, we must first change ways of *seeing*.

In that spirit, *Birds Watching* reminds us that *truly seeing* is a reciprocal act. Mass media imagery and omnipresent screens skew our sense of vision toward a one-way consumption, contributing to our feeling of being at a remove from the world. When we fall into this limited, nonparticipatory vision, what we see tends to confirm our biases and stereotypes—flattening other beings, like birds, into "things." This objectifying gaze has become the default, but what about other gazes: the gaze of mutual curiosity, the gaze of respect—or even of love? Can we re-enchant the way we see, and bring back the full depth of field and depth of feeling?

Most potently, when our act of seeing is reciprocated by another being, this mutual gaze involves us in an active participation with our vibrant biosphere. Relearning the ability to look deeply at nature engages us in this enfolding, participatory world—emphasizing that we cannot solely be spectators in the age of the Anthropocene—this new era when our empathy for other beings, or lack thereof, has itself become an ecological force. *Birds Watching* reminds us that when we look at nature, nature looks back. *Truly seeing* can be a first step toward practicing a renewed ethos of mutualism and care.

Underground Library is a long-term project based around a collection of five decades of books on climate change—from unread technical manuals to forgotten best sellers. It represents a printed history of individuals' and groups' calls to urgent action—which remain largely unheeded by a world enraptured by an economic death cult.

As carbon dioxide is added to our atmosphere's natural carbon cycle by anthropogenic processes, our world warms. Left alone, fallen trees and even our own bodies eventually return their borrowed carbon to the atmosphere—unless it is sequestered in some way. The creation and burial of biochar is one method of sequestering carbon. Pioneered by indigenous peoples of the pre-Columbian Amazon, and gaining popularity in modern, sustainable agriculture, biochar is traditionally created from wood or other biomass using a low-oxygen pyrolization process that leaves behind a highly stable form of carbon.

For *Underground Library* this process was replicated with these overlooked texts—books' paper being wood in another form—"restoring their use value" by preventing their carbon from entering the atmosphere. At the conclusion of *Indicators*, these biocharred books will be buried, becoming a permanent part of the landscape at Storm King—sequestering their carbon for millennia to come and creating a literal underground library.

— *Statement by the artist*

Underground Library, 2017–18
Selections from a library of books on climate change,
biocharred to sequester carbon
Dimensions variable
Courtesy the artist

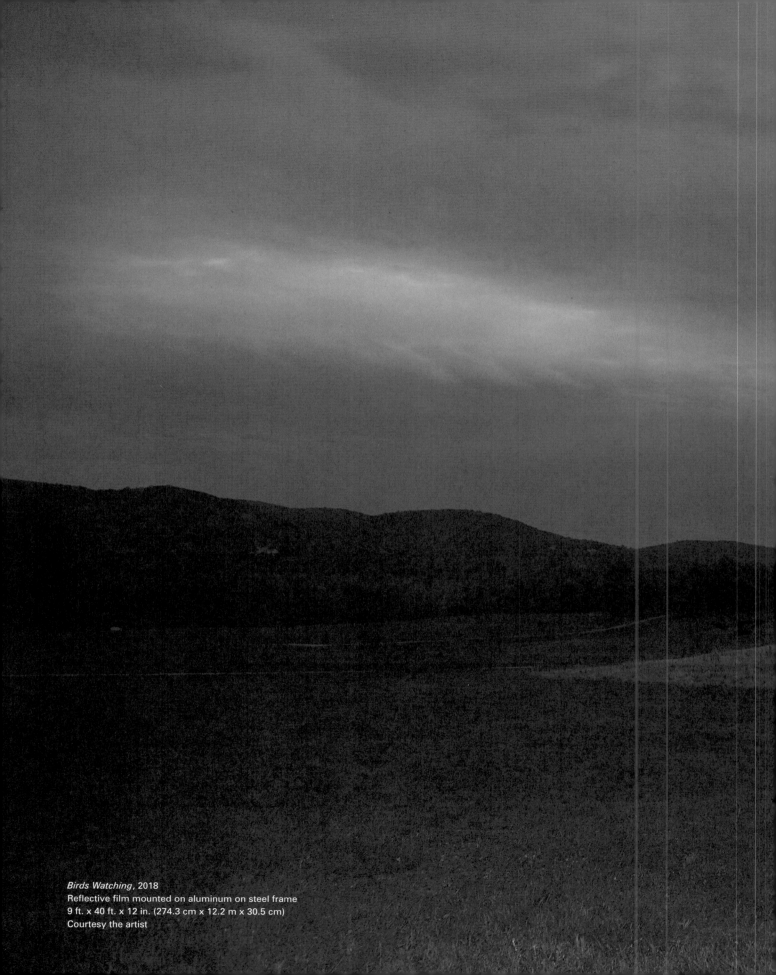

Birds Watching, 2018
Reflective film mounted on aluminum on steel frame
9 ft. x 40 ft. x 12 in. (274.3 cm x 12.2 m x 30.5 cm)
Courtesy the artist

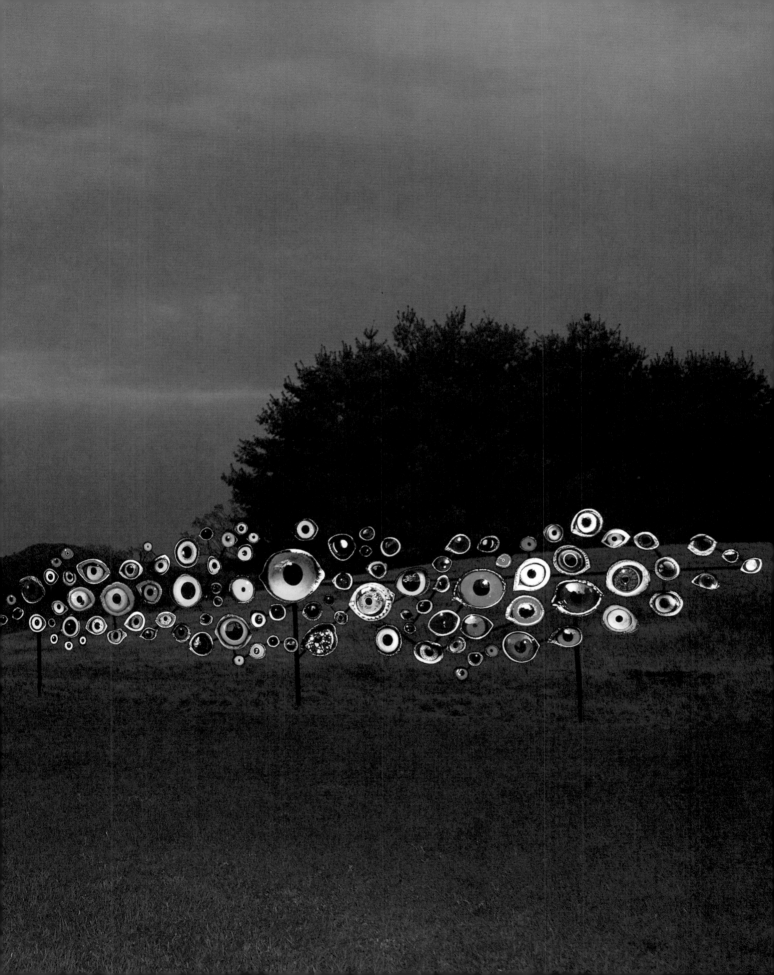

MAYA LIN

Through my art, I have been focusing on climate change, both its effects as well as possible ways to reduce the emissions that contribute to it. In Storm King's Museum Building, I have two works that focus on what we're losing as far as Arctic and Antarctic sea ice. They are two extremely thin white encaustic wax relief sculptures that chart the disappearance in area of the ice at both the North and South Poles, and also call attention to the rapid thinning of the ice—which makes it, specifically in the Arctic, much more vulnerable to melting from underneath.

For the work outdoors, I wanted to bring attention to a possible solution to climate change. *The Secret Life of Grasses* comprises three living grasses in which the root system of each is transplanted to a ten-foot-tall clear PVC tube. Over the course of the summer these grasses should continue to grow, revealing how deep their root structures can become and showing how within these root structures an extremely complex carbon cycle takes place that allows the grasses to fix significant amounts of carbon, removing it from the atmosphere.

People may not realize what's going on literally beneath our feet. I want to make you aware of what we're losing, but I also want to say, "There are ways out of this." I'm really excited about allowing people to come face to face with the complexity of these incredible root structures, and to make people aware that nature-based solutions—such as restoring our grasslands, reforming agriculture, reforming ranching, protecting our forests, and restoring our wetlands—could effectively reduce our overall global emissions by more than fifty percent.

When I did *Storm King Wavefield* (2007–08), I worked with Darrel Morrison, the plant expert here. Over the years, Storm King has gone through a complete transformation, from much more cultivated lawns to the more natural landscape you see today. For this current work I knew I wanted to focus on grasses. And I recalled that Darrel had reintroduced many prairie grasses at Storm King.

With the help of The Land Institute in Salina, Kansas, I was able to bring two prairie grasses—a switchgrass and a big bluestem—both of which are also native to New York and were reintroduced by Storm King. A third grass, called kernza, is a perennial food crop grass that The Land Institute helped to develop. This grass could help feed more people and help restore the life of the soils. Modern-day industrial agriculture has contributed to the loss of more than a third of the world's arable land and has been a major source of carbon. These totemic sculptures help show how these living systems can actually become a carbon sink, while also helping to increase biodiversity.

Through a foundation I founded, called What Is Missing?, I have been focusing attention not just on what we are losing in terms of biodiversity, but emphasizing that by protecting and restoring habitats we can both protect species and reduce carbon emissions in the atmosphere. The foundation produced a booklet that highlights the ecological history of the American prairie and describes how these living systems can help combat climate change. This booklet is available at Storm King through the duration of the exhibition.

— *Excerpt from an interview with Storm King Art Center*

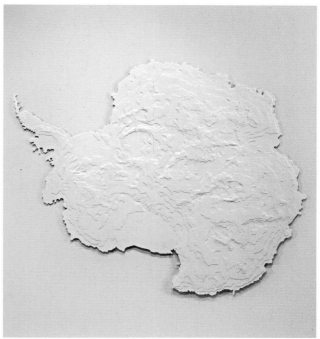

59 Words for Snow, 2017
Paperboard, encaustic, and aluminum
53 ⅛ x 50 ¾ x 2 ½ in. (134.9 x 128.9 x 6.3 cm)
Artist's proof
Courtesy the artist and Pace Gallery

Before It Slips Away, 2017
Paperboard, encaustic, and aluminum
54 ¾ x 65 ⅝ x 2 ½ in. (139.1 x 166.7 x 6.3 cm)
Edition: 2
Courtesy the artist and Pace Gallery

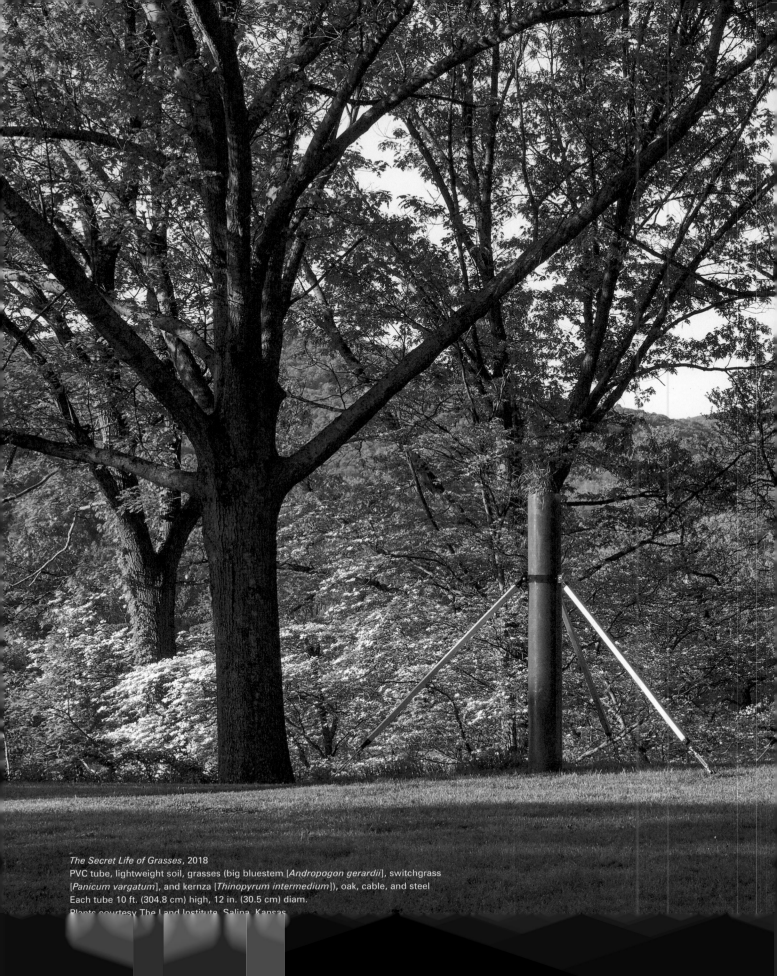

The Secret Life of Grasses, 2018
PVC tube, lightweight soil, grasses (big bluestem [*Andropogon gerardii*], switchgrass
[*Panicum vargatum*], and kernza [*Thinopyrum intermedium*]), oak, cable, and steel
Each tube 10 ft. (304.8 cm) high, 12 in. (30.5 cm) diam.
Plants courtesy The Land Institute, Salina, Kansas

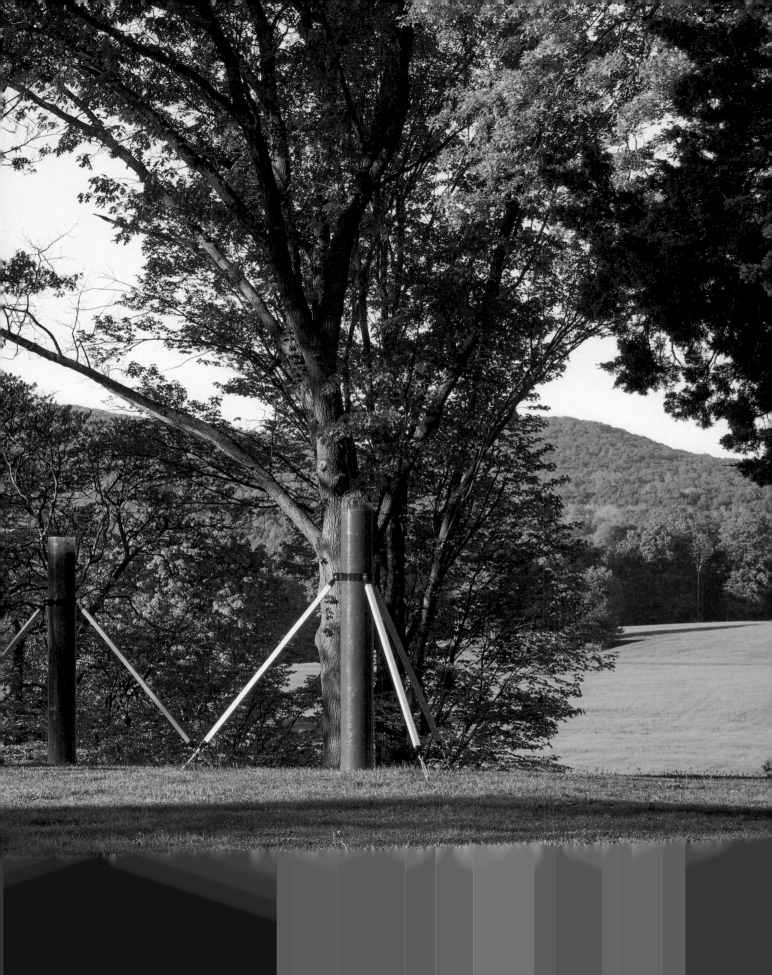

MARY MATTINGLY

Along the Lines of Displacement: A Tropical Food Forest is a project that involved bringing tropical fruit trees—a coconut palm, a ponytail palm, and a paurotis palm—from Florida to Storm King, installing a "living sculpture" on the Museum's grounds. The trees that we brought from Florida grow in agricultural zones 8 and 9, and they have just been planted in the current agricultural zones 4 and 5. The effect of witnessing these plants in a Northeastern setting is uncanny. This is partly an experiment, exploring the potentials for growing different plants in different climates, but it is also a provocation: a proposal for a future that is predicted for the turn of the next century, when a 4-degree Celsius [7.2-degree Fahrenheit] temperature rise is the baseline for what we will all inevitably feel with climate change. Migration (of all species, including humans) is often directly linked to climate change.

The impetus for this project came from a trip that I took to Alaska in 2014, to witness a conference where politicians from Washington, DC, came to Alaska to meet with heads of native corporations and representatives from Shell Oil to discuss the melting of sea ice in the Arctic, the Northwest Passage, and how that could affect people's livelihoods—subsistence hunting, specifically—as well as laws regarding drilling for oil. I was able to listen to that conversation through an initiative to bring artists as listeners, undertaken by Julie Decker at the Anchorage Museum. What I learned from that trip was that as the Arctic warms, and as parts of Alaska warm, people are starting to farm in a place that is being called a fertile crescent, which runs through the center of Alaska. And people are exploring agroforestry in places where, in the past, it has been so cold that much food hasn't been able to grow.

The response that I had at the time was one of sadness for an idea of a place I had idealized but never really been to or known, and also concern about the multitude of ways a melting Arctic will lead to a quickening of climate change around the world. While there, I tried to learn what a warming climate meant to people I met in Alaska, where food is expensive and food security is so necessary, and of course it's complex. Alongside these changes come potentials for other types of food security, and that conversation is one that, if it isn't had, may mean we miss out on potential ways of addressing resiliency and even regeneration within climate change.

Along the Lines of Displacement triggers a form of storytelling and imagination around climate change. It is a sister project to *Swale*—a floating food forest on a barge in New York Harbor. I founded *Swale* in 2016; it's Land art on the water, and it's a place where anyone can go to pick fresh food for free. In a city where fresh food is found in farmers' markets, community gardens, and expensive supermarkets, growing or picking food on New York's public land has been illegal for almost a century for fear that a glut of foragers could destroy an ecosystem. An edible landscape on the water utilizes marine common law in order to circumvent public land laws in New York. *Swale* came out of ascertaining that in addition to more than one hundred acres of public/private community garden space in New York City, the city cares for thirty thousand acres of public parkland.

The idea with *Swale* is very similar to this project. It's an architectural folly that's out of place—that brings people into a conversation about food security, resiliency, and ecosystem health. It also gives

another form of access to fresh food in a city where it is very expensive, if you can find it at all. In public space, it can influence policy. As a direct result of *Swale* and the support of community groups, the New York City Parks Department just opened their first land-based project, a twenty-four-hour public "foodway" at Concrete Plant Park in the Bronx.

So, in one way, this project questions the potential food sources in New York's future, with global warming. What conversations happen around that? They're going to involve policy, loss, love, and also hope. How do those conversations relate to migration?

The New York City Parks Department carefully cultivates what are deemed native plants in public parks. These plants have been found to contain properties that create pollinator pathways for insects, strengthen soil quality, ward off disease-carrying insects, and maintain a level of plant biodiversity by not crowding out other plants. This work can and does slow down effects of climate change, but it is what is considered a Band-Aid approach, as it does not and cannot effectively change the workings of a dominant, industrialized system based on specialization rather than holism. Plants that are brought to or that migrate to a place and begin to engulf an area are considered invasive. There is a dialogue about how this parallels human movements; from those who move with some modicum of choice to climate refugees who are forced to relocate, the concern arises: who or which entities are controlling their movements, and is that control ethical, or in some cases, is that movement ethical? While solutions to these topics are complicated, nuanced, and never universal, this piece takes the position of living with, and maybe even (one of my recent favorite quotes by Robin Messing) *holding, not having*.

There is an organization in Salina, Kansas, called The Land Institute, where scientists like Stan Cox are working on breeding back perennial strains of commonplace foods like corn and sorghum that have been all but lost in industrial agriculture, and restoring a plant's natural tendency to replicate and to grow back year after year. Projects like that are happening around the country, and around the world, and they have really been an inspiration to this type of work.

Along the Lines of Displacement uses the language of a folly to organize something that's out of place in an environment where it's unexpected—people might be able to go to Storm King and harvest fruit from a palm tree during this exhibition. What can we speculate about the future of upstate New York, and what are the more messy stories and assumptions surrounding these speculations? Our different ways forward may be unnerving and loss-filled, but also potentially full of promising ways of living and being. For me, this work is a reminder that a continued awareness of our interconnectedness leaves us with less room for idealization or indifference.

— *Statement by the artist*

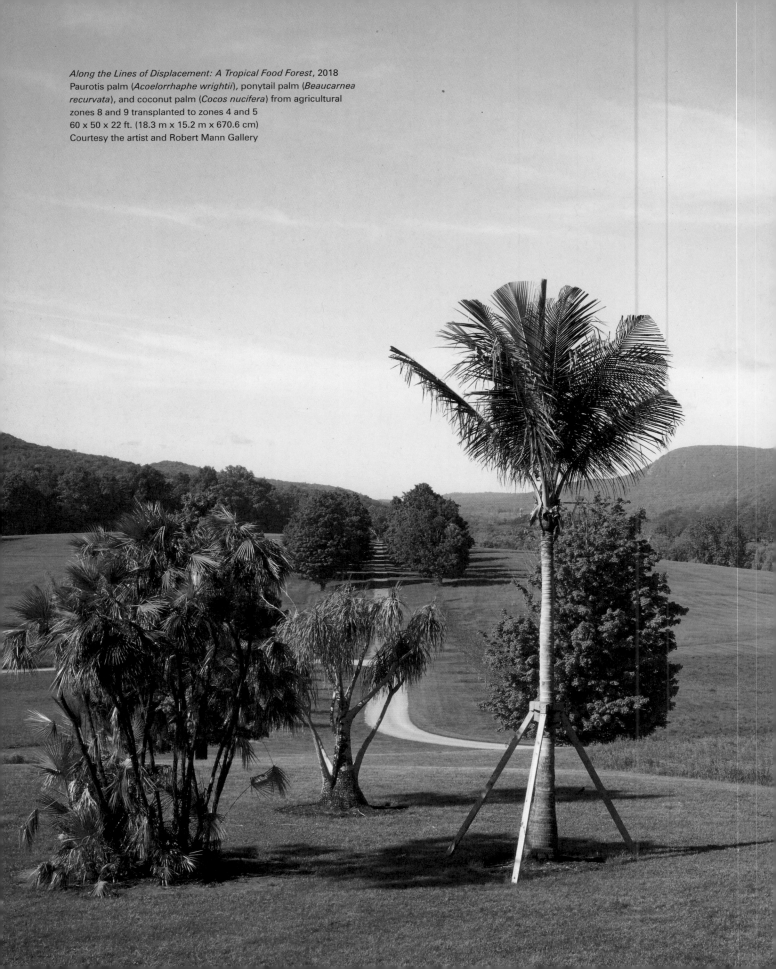

Along the Lines of Displacement: A Tropical Food Forest, 2018
Paurotis palm (*Acoelorrhaphe wrightii*), ponytail palm (*Beaucarnea recurvata*), and coconut palm (*Cocos nucifera*) from agricultural zones 8 and 9 transplanted to zones 4 and 5
60 x 50 x 22 ft. (18.3 m x 15.2 m x 670.6 cm)
Courtesy the artist and Robert Mann Gallery

ALAN MICHELSON

Wolf Nation is a contemporary, electronic wampum belt that speaks of the urgent condition of our cross-species indigenous relatives: in this case, red wolves.

Wampum refers to beads made of shells: white beads from whelk shells, and purple beads from quahog shells. Indigenous people liked clams, not only for the food but for the shells, which are so permanent, hard, and beautiful when polished. Natives developed a technique to shape them into small cylindrical beads, and weave them in digital-like matrices into wampum belts. The contrasting beads were woven into glyphs that enshrined a certain event, or an important agreement. You could say that they were recordings, mnemonic devices, and they were good size, wider than they were tall. I like this format because it is something based in my Haudenosaunee culture.

The Lenape, the people indigenous to the land that is now Storm King, also had wampum belts. Nations on Long Island were the main wampum makers. Belts with predominantly purple beads connoted urgency and seriousness: *Wolf Nation* is one of those, a warning and declaration of indigenous cross-species solidarity and advocacy for our wolf cousins. I'm using digital video of the red wolves for this work, not shells, but relating beads to pixels.

We Mohawk have three clans—Wolf, Bear, and Turtle. I've always wanted to do a piece honoring the clan animals. This exhibition, with its theme of climate change, seemed like the best opportunity to do that, and to do it in a way that was site-specific, which is the way I work.

I usually start with a site, a place. I've visited Storm King in the past and it's a beautiful site. I have done some pieces on the Hudson River and I'm aware of the indigenous history of the area. Mohawks are from what's now Upstate New York. We were dispossessed of our territory during the American Revolution. My ancestors were part of the Haudenosaunee that moved up to what's now southern Ontario after the American Revolution. We were essentially driven off of our homelands, as were the Lenape people, whose territory stretched as far south, I think, as Delaware, and as far north as Orange County in New York.

Their northernmost group was called the Munsees. They were also known as the Wolf tribe, because wolf was their dominant clan animal. I saw parallels between the shared fate of the Munsees and the local wolf population, which was eradication from their territory. Both groups suffered as a result of the colonial mentality, the extractive, land- and resource-hungry approach, the approach of dominance rather than collaboration. It's this extractive mentality that clears forests for short-term gains. Eventually, you reach a point of no return. A relationship with nature in which you're not including yourself in a very primary way, instead seeing yourself as manager or boss, turns everything into objects, turns living beings into things to be harvested.

The Wolf Conservation Center in northern Westchester protects and preserves wolves, including the direly endangered red wolves, an indigenous species. There are only thirty left in the wild. When I visited the center, there was an introductory presentation with revelations about the important role of wolves in the ecosystem, related to the reintroduction of wolves to Yellowstone National Park.

A slide showed a landscape in Yellowstone before the reintroduction, an open area with sparse, low vegetation bordered by trees. The next slide showed the site a few years after the wolves' return, and the low growth had noticeably filled in. Without wolves to hunt them, the deer had been overgrazing, and that affects everything on that land. Everything changes when there is ground cover; it changes the temperature. You wouldn't necessarily factor wolves into the climate change equation, but like all of nature, they are part of the larger picture.

At this point it's important for people to think about the traditional knowledge that indigenous people have regarding a very different relationship to nonhuman life. If you consider the rest of the world, and not only human life, as your relations, you have a very different perspective. It's a reciprocal, kinship relationship: you wouldn't murder your relatives. Why not honor all the other life on the planet? It's all of a piece.

At the wolf center I heard the wolves howl. Even if it's a cliché, the two-note "awoo" wolf howl, there's still something thrilling about hearing them. They're responsive. When a human starts a howl, the wolves will adjust their pitch to it, which is a beautiful responsive thing. Responding in turn, I thought it would be interesting to bring the wolves' voices into the piece, and so I commissioned my friend, colleague, and collaborator, the extraordinary White Mountain Apache composer and musician Laura Ortman, to create a soundtrack from found audio of wolf howls. The result of her sampling, editing, and conditioning is the beautiful, haunting soundtrack of *Wolf Nation*, a sustained lament.

— *Excerpt from an interview with Storm King Art Center*

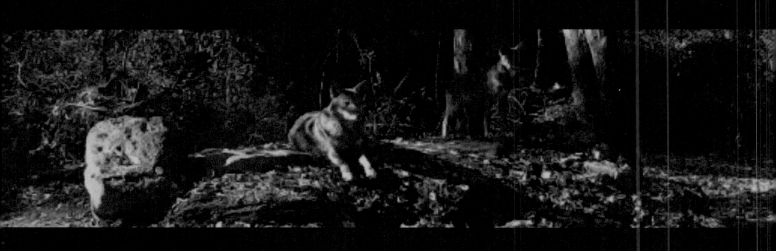

Wolf Nation, 2018
High-definition video (color, sound)
9:59 min.
Sound by Laura Ortman
Courtesy the artist

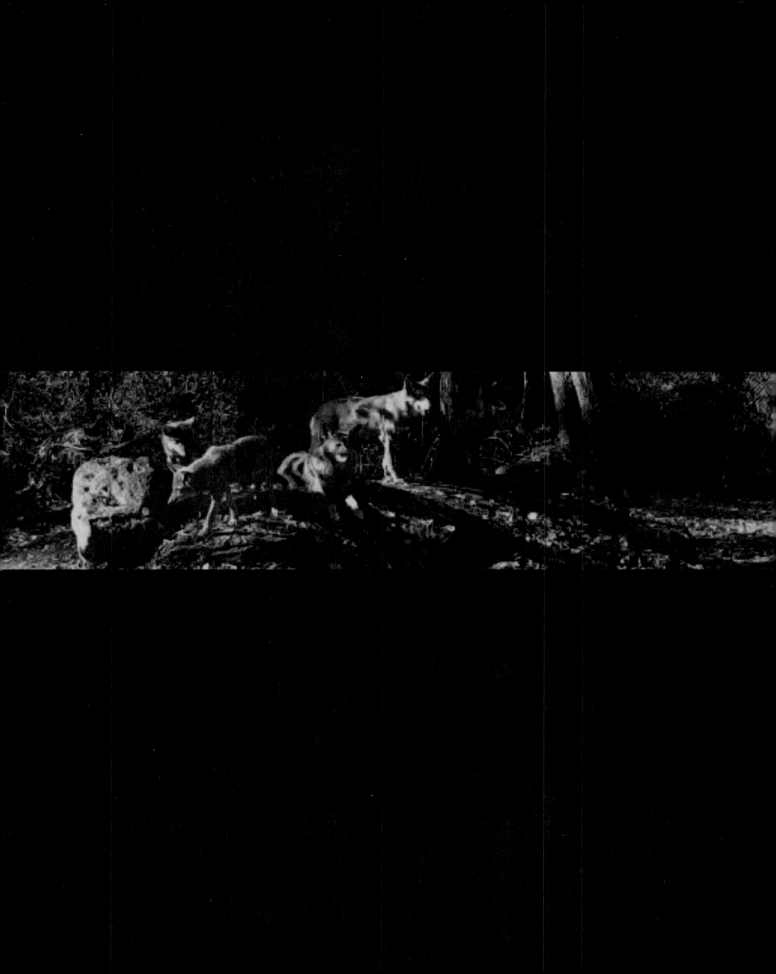

MIKE NELSON

Eighty circles through Canada (the last possessions of an Orcadian mountain man) was part of a larger exhibition in 2013 at the Contemporary Art Gallery in Vancouver. The work for that show was primarily made from debris collected from the beaches of the northeast Pacific Ocean, and referred back to a body of work I had made in the 1990s based around a fictional motorcycle gang called The Amnesiacs. These first works were born out of a residency I spent in Berwick-upon-Tweed, in the northeast of England on the North Sea coast. The original premise of the work was from the perspective of a lone beachcomber, akin to a character from a J. G. Ballard novel, collecting debris from the beaches and treating it almost as if it were an encoded language. This idea borrowed from another science fiction novel from the early 1970s, *Solaris* by Stanislaw Lem, in which the surface of the planet Solaris is covered by a sentient ocean. In the novel, cosmonauts visit a space station on Solaris where they are driven mad by their own hallucinations made real; in the case of the protagonist, his dead girlfriend returns only to realize that she is not the "actual" person she perceives herself to be.

The first weekend I spent in Berwick I learned of the fatal climbing accident of my friend and collaborator Erlend Williamson in Glencoe, in the Scottish Highlands. My narrative then took a complicated turn as the loss referenced in *Solaris* became real for me, and the plot of my proposed work became entwined with reality.

The idea of the biker gang came about because I had become interested in Soviet science fiction and its use of allegory to communicate subversively with readers, including those of the West. I invented a gang that would help me to decipher the matter washed up on the beaches and to try and make sense of it—whatever "it" was. I named them The Amnesiacs after an early Hal Hartley film, and because the loss of my friend created a sense similar to that of amnesia.

I visited Vancouver on the premise of making a new work with The Amnesiacs, comparing them to the Canadian landscape painters known as the Group of Seven—which formed in the early twentieth century following the death of their friend and painter, Tom Thomson. Thomson died in a canoeing accident in the Canadian wilderness. However the gang was also shadowed by another mythic piece of Americana—the mountain man. I wanted to equate the structure of the biker gang with that of the hunter and trapper, focusing on the idea of territory as well as the historic romance in fiction of the white male outsider in the wilderness. I was keen to aggravate these ideas by considering their economic and political underpinnings: one by the fur trade, with its imperialist interests in the nineteenth century, and the other, in more recent times, by drugs and gang-related territorial interests.

I also like the idea that my friend, Erlend, whose ancestry was from Orkney, an island in northern Scotland, could somehow emigrate to Canada through his last possessions. In the early nineteenth century the Hudson Bay Company, which was based in London, would advertise specifically in Orkney for people to go to Canada to become trappers pursuing furs and territory. The Hudson

Bay Company rightly perceived that people in Orkney lived a very hard life in a harsh environment, similar to that of parts of Canada; also, the islands lay on the route from London to North America, so it was convenient to stop on their regular journeys and pick up anyone who was willing.

Erlend's possessions were given to me after the death of his last parent. At first it seemed macabre, but ultimately I came around to the idea. It felt almost fateful, and became a fitting memorial to our friendship and working methods. The objects were the remaining detritus of his life and of little or no value to anybody other than a close friend: boxes of photographs, collections of rocks and photos of the mountains they had come from and that he had climbed, his old boots. Even a plaster cast from when he broke his arm in his early twenties. Two friends sent me some pictures of his stuff, and images of the coastline and the beach in Orkney. I thought about these things in relation to this show I had proposed and thought, well, what would Erlend have thought? Would he like to come on this adventure with me? So, in a sense, that was the beginning of the idea for *Eighty circles*.

In the buildup to the exhibition I visited the anthropological museum in Vancouver and was transfixed by a slide projection of images of the Canadian west coast in the '60s and '70s by a local anthropologist, Walter Duff. I also did a two-week residency in Banff where I focused on the possibility of using projection. It was on this trip, whilst driving around and looking at the landscape of the Rockies, that I fell upon these strange stone circles that people had left after camping, simple barriers to contain a fire. They seemed so primal. I planned a trip from Banff to Vancouver seeking out more stone circles and documented them on slide film, eighty in total, enough to fill a carousel. The images are projected onto the back of a structure held up by shelving made out of off-cuts of plywood that had been washed up on the beaches of Vancouver, on which Erlend's last possessions are placed.

While the work wasn't made directly in relation to climate change, it talks about our world through its reference to Solaris and the idea of a sentient planet. It also tries to reevaluate Land art in relation to its political currency—literally that of land itself. The title alludes to a certain lineage of British Land art, through artists such as Richard Long. This was a space that Erlend himself would most probably have occupied should he have lived. However the work's main drive is the idea of loss, whether on a personal or a global level. In this arena it is a bleak work—for humanity at least. I am reminded of the first incarnation of The Amnesiacs in 1997, titled *Master of Reality*, which included a darkly comical sticker proclaiming "Extinction beckons." Its humor is particularly cruel when one considers its placement on an old motorbike helmet, an object from a future archaeology perhaps, with a fitting epitaph for humanity itself.

— *Excerpt from an interview with Storm King Art Center*

Eighty circles through Canada (the last possessions of an Orcadian mountain man), 2013
35mm slide projection (eighty slides), 50mm lens, ply-driftwood, plywood sheets, metal chains,
and the remaining personal effects of Erlend Williamson (deceased)
Shelf and screen: 9 ft. x 13 ft. 6 in. x 15 in. (274.3 x 411.5 x 38.1 cm)
Courtesy the artist and 303 Gallery, New York

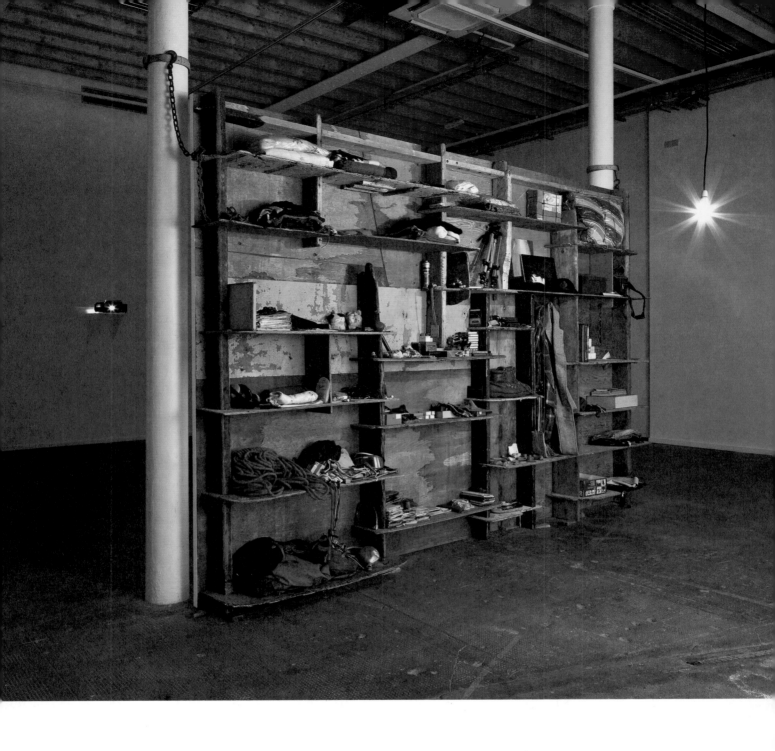

STEVE ROWELL

Midstream at Twilight is an experimental documentary film about the oil pipelines that run from the tar sands of Alberta, Canada, to the Chicago area and beyond. I visually trace the pipelines, which are a liminal infrastructure—meaning barely visible, oftentimes hidden for security reasons and for safety reasons, I suppose, but also because the oil industry keeps its precious cargo, a dangerous and toxic fluid and a highly contentious substance, out of the public purview. I used a drone to film most of these locations from above, which allows for both oblique and direct, straight down perspectives of the landscape. The film includes quite a bit of footage that I shot up in the Athabasca tar sands in northern Alberta, as well as at locations across Minnesota, Illinois, Indiana, Kentucky, Kansas, and California.

The film has political underpinnings, mostly because of my own perspective on the oil industry and the issue of climate change. The film was commissioned by the Natural Resources Defense Council (NRDC) for *Petcoke: Tracing Dirty Energy*, a 2016 exhibition at the Museum of Contemporary Photography in Chicago. Artists made work about these extremely large piles of petroleum coke—or petcoke—a byproduct of refining tar sands oil that has been piling up on the South Side of Chicago. These petcoke piles were affecting the local communities because of the toxic particulate matter that blows off of the black piles into surrounding neighborhoods.

I decided to focus on the "midstream" segment of the oil industry. It's basically the transportation, distribution, and storage of oil from the extraction points to the places in which the oil is converted to sellable product. Midstream also refers to something ambiguous, in between. "Twilight" refers not just to the literal twilight of the setting sun, but to an ambiguous end to something. It's my wish that the oil industry will at some point end—it's necessary to help decrease the effects we're having on the atmosphere and the environment. The film functions as a death curse against the industry.

Not only did I find out where this petroleum coke comes from, which in this case is a BP refinery just across the Illinois-Indiana state line, but where the oil from which it originates comes from, which is the tar sands of Alberta. I also tried to figure out where it goes from Chicago. I filmed a few locations in Kentucky and southern Illinois, where I managed to trace it. I ended up following the petcoke all the way to the ports of Los Angeles and Long Beach, where it gets loaded onto cargo ships and is sent to China where it's burned in power stations to generate electricity. The irony, of course, is that emissions from these power plants flow back across the Pacific by way of the jet stream, and then are dumped back onto California.

The film features a bit of the soundtrack from *A Clockwork Orange*: a version of a Henry Purcell piece from 1695—a funeral dirge basically. That date is particular because it was just before the Industrial Revolution really started in the eighteenth century. I see this as a way of marking the beginning of the industrial era, but then including this highly synthesized version from *A Clockwork Orange* by Wendy Carlos as a way of marking the near end of the industrial era. It's a strategy I'm

using to try to bring about a heightened awareness of accelerating climate change and by being hyperbolic about the hyper-violence wrought on the landscape by the oil industry.

About half of my time is spent researching—the points of interest, the sites in between—and then conceptualizing the project from there. Once I get a map established, that's when I get my ideas going about how to make the work, and how to represent the landscape or how to aestheticize it in some way beyond just documentary photography or cinematography.

I did manage to find quite a few sites beyond the obvious. It took quite some time to figure out where these pipelines travel—the exact locations—because they want to keep that classified to some extent. Pipeline maps are vague and low-resolution. Once I discovered, approximately, where these buried lines were located, I then traced them onto an interactive satellite-imagery map. After zooming in further, I could find their precise locations as evidenced by changes in the color of foliage or the dirt. Beneath highways, surface markers are required for safety reasons. I could visually spot these using Google Street View photography in many cases. After using these free online tools, I traveled to the specific coordinates to conduct filming. These are some of my strategies for field-based artwork.

After the petcoke leaves the Chicago area, I really just had to hunt around, trying to spot barges as they move down the Illinois and Michigan Canal and the Mississippi River, or trying to find out where a rail spur might be that would have trains loading the stuff onto or off from a train or barge. I managed to find out one of those locations just by having a really strong hunch, driving four hours to Paducah, Kentucky, and waiting until I saw a barge pull up. Using my intuition, I got lucky.

Because Koch Industries is part of this story, I decided to include it in the film by way of visiting Wichita, Kansas, and filming not only the company's global headquarters, but the Koch family estate as well. It then becomes clear that the company and the Koch family is part of the story, part of the problem, and part of the decimated landscape that we all share. It's a horror film in some ways, but it does have a lot of beautiful and hopeful moments, I think.

— *Excerpt from an interview with Storm King Art Center*

GABRIELA SALAZAR

Matters in Shelter (and Place, Puerto Rico) was conceived in response to Hurricanes Maria and Irma devastating Puerto Rico in the fall of 2017. Although the humanitarian crisis still occurring on the island was set in motion long before Maria by colonialism and capitalism, it was brought to a new level of urgency by the predictable disaster of that super-powerful hurricane.

My parents are both from Puerto Rico. The tent-like structure of *Matters in Shelter* is partially derived from my mother's description of a *semillero*, or hothouse, used to nurture young coffee seedlings on her family's coffee farm; the mesh tarp that covers my shelter is blue, reminiscent of the FEMA tarps that still dot the landscape in Puerto Rico. Inside, the floor and platforms are made of concrete blocks.

Concrete has become an increasingly necessary building material as climate change causes hurricanes to become more powerful. Yet cement production creates five percent of the carbon dioxide emissions worldwide, second only to energy production. Cement is the second-most consumed commodity on Earth, after water. The use of cement directly contributes to its own necessity.

Coffee is entwined with Puerto Rico's agricultural and colonial legacy. Coffee was also, until Maria, an industry experiencing a revival in the faltering Puerto Rican economy. Some estimate that more than eighty percent of Puerto Rico's coffee crop, which was ready for harvest just as Hurricane Maria hit, was devastated by the storm. Coffee farming is labor-intensive; trees take three years to bear fruit and beans are harvested by hand. Coffee also uses a lot of energy in its journey from bean to the disposable paper cup in your hand. While coffee holds a familial importance for me, it's also a commodity that is problematic, especially at an industrial scale.

In a piece from 2015 called *My Lands are Islands*, I used a homemade coffee-clay to make works that were inherently unstable. The clay was made only of used coffee grounds, flour, and salt, and then pressed into molds to dry. For *Matters in Shelter* this same clay is now being made in the form of concrete blocks. As the coffee blocks crack and fall apart, I will replenish them. The maintenance component of the work feels analogous to making art, and mirrors my concerns for Puerto Rico's position in relation to the United States, and what I can do about it—a sort of circumscribed persistence and insistence.

I was drawn to Storm King's Maple Rooms as a site that redoubles the forms (the rectangle of posts) and themes in the work. Although all of Storm King is a constructed landscape, the relationship of the human and the natural, the planned and the entropic, is especially visible in the Cartesian grid of maples high on the hill at the edge of the woods.

How do you deal with the existential position of rebuilding while knowing there will be another hurricane; when the materials and resources you have are inadequate to—and even contribute to—the problem? *Matters in Shelter* makes this Sisyphean act visible. Though permeable, the structure provides a buffer to the rain, wind, and sun. This modest protection makes space for persisting in the daunting act of repairing and rebuilding, and asks us to consider how we could do it better.

— *Excerpt from an interview with Storm King Art Center*

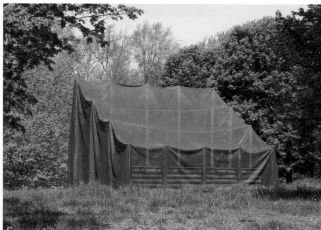

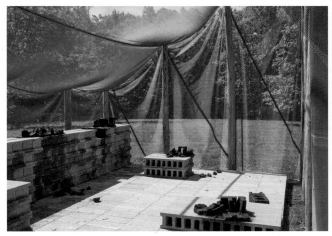

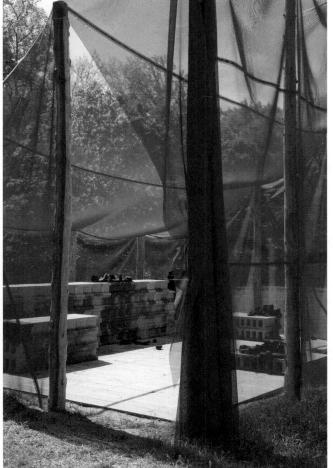

Matters in Shelter (and Place, Puerto Rico), 2018
Coffee clay (used coffee grounds, flour, salt), concrete block,
wood, and polypropylene mesh tarp
12 x 16 x 20 ft. (365.8 x 487.7 x 609.6 cm)
Courtesy the artist

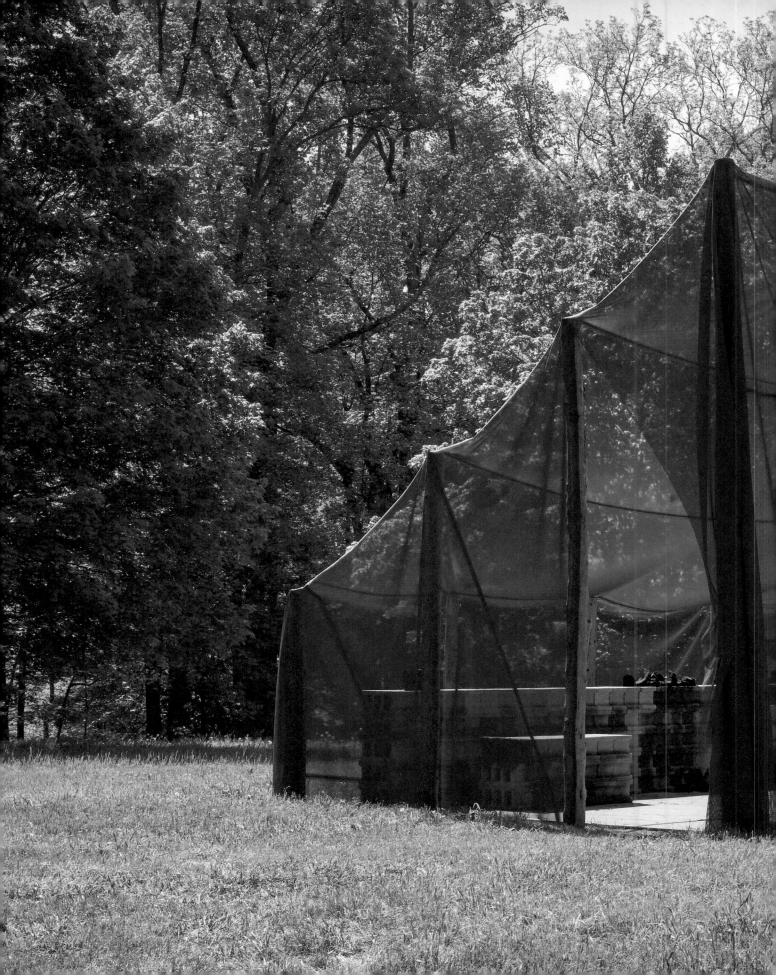

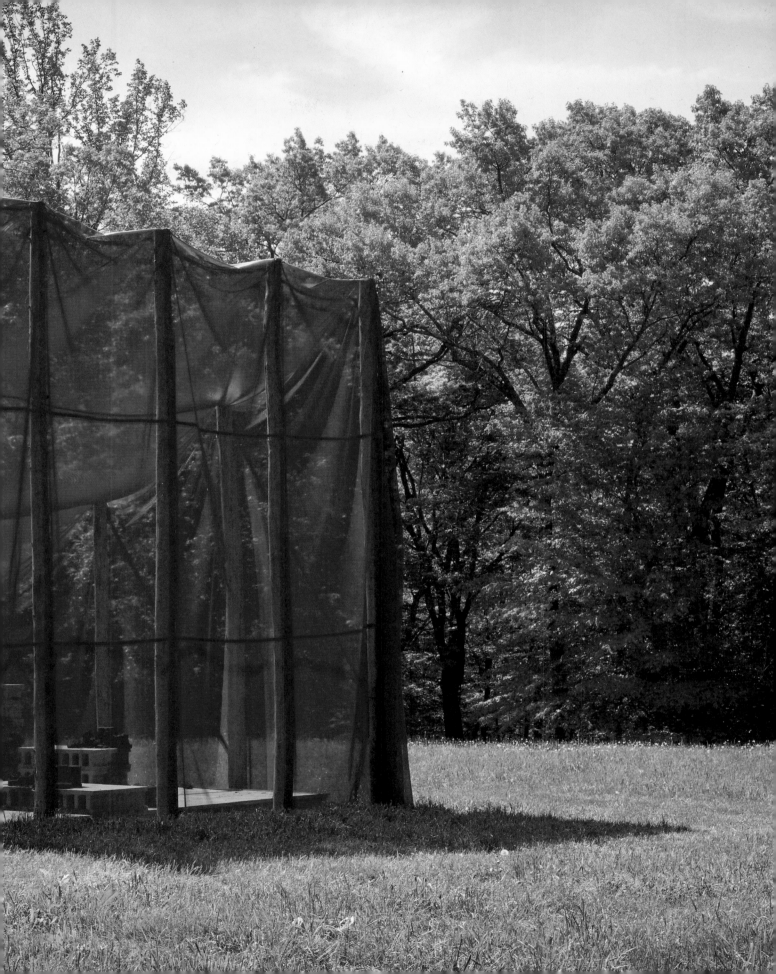

REBECCA SMITH

Maquette for Weather Watch is one of a group of works I made leading up to a large outdoor sculpture called *Big Reuse*. The original idea came from the fact that, literally, we are all watching the weather because the climate is changing in very alarming ways. One must watch the weather. In a sense, we are all in this big science experiment together thanks to a process that began more than five thousand years ago when human habitation started to make an appreciable impact on the biosphere. Early human use of fire, the development of agriculture, the advent of globalization in the fifteenth century, industrialization—humans have been substantially altering Earth's environment for thousands of years. Now CO_2 levels in the atmosphere are reaching a crisis point and our weather is on a roller coaster, and the net result is extremely rapid warming. How will this human experiment on planet Earth turn out?

I wanted *Weather Watch* to be a transparent structure you see and could see through to see the weather and the world. I want it to encourage—and reward—looking.

I first took on the subject of climate change in 2005, after a trip to Australia. At that time, and particularly in the southern hemisphere, there was an ozone layer crisis. I experienced how piercing the solar rays were in that different part of the globe. I heard that Australians were told to have their skin checked for cancer twice a year. The next year, Elizabeth Kolbert's *Field Notes from a Catastrophe* was published, and I read it with a sense of alarm and foreboding. I could no longer fend off climate change. I had to think about it. I had to do something about it.

My work at the time was very abstract: grid-based, steel wall sculptures, all blue, very structural. I decided to give them all names of glaciers. Melting glaciers were one of the first signals of global warming that captured the public's attention—it was like the canary in the coal mine. If you are an abstract artist, how do you put content front and center? This has been central to my project ever since.

The important task ten years ago was to convince people that climate change was real. I think that case has been made by now. Convincing people of the cause is still somewhat of a struggle, as is changing the way we do things.

Maquette for Weather Watch started out as a weather watch tower—an image I gleaned from Margaret Atwood's *MaddAddam* climate trilogy: a postapocalyptic world where there are only remnants of the structures of our civilization left, and a few people wandering around living off of old junk food full of preservatives. They take over abandoned buildings that are falling apart, and start reusing and rebuilding them. The structure I imagined was both from the past and from the future—degraded, a survivor, reclaimed and repurposed by future humans. I got this title—*Big Reuse*—from a recycling center/construction store in Brooklyn; I like their casual way of saying we must salvage what we can and do it over again better in a big way.

We have to have big ideas, a big reuse: keep what we can work with, but abandon a lot. We will be forced to let go and do things differently.

My reading and research about climate, including the imaginings of fiction writers, gave me the mental image of an architectural form and I wanted to build it. I saw it as a steel form—steel being the

underpinning structure of the industrial world. I used color as signaling pathways on the surface—the ocher, white, black, and raw sienna that were the first colors used by humans in art, as well as neon green, yellow, and orange, which are contemporary industrial inventions.

The base in sculpture is an ongoing preoccupation. I put this small-scale sculpture on a support made of mycelium—a totally biodegradable, cheap material made from the fiber that helps cultivate mushrooms. Two engineering students developed it in a college invention class and started a company, Ecovative, in Green Island, New York. Their patented mycelium product is now widely used for packing and construction materials. The company also makes little end tables that have a recognizably Brancusi shape, especially when you put two together as I did. The piece has a relationship to classical modern sculpture both in the Brancusi-shaped base and the steel grid form.

One of the uses of sculpture—ancient and contemporary—is as a monument and memorial that defeats death and loss. I like using materials that are going to last, at least for a while.

I think the artists working on climate issues are so inventive—they must be. Given the enormity of the challenge, there's just no easy way to do this. I think, however, that we are already accomplishing something important. Things are changing. People are watching. People know—apparently seventy percent of Americans recognize that there's human-caused climate change, and they want something to be done about it. We can't worry about the diehards. We need to focus on what we people who see the problem can do about it.

— *Excerpt from an interview with Storm King Art Center*

Maquette for Weather Watch, 2013
Steel, plywood, and mycelium by Ecovative
66 x 28 x 28 in. (167.6 x 71.1 x 71.1 cm)
Courtesy the artist

TAVARES STRACHAN

It is not possible to have an artistic practice without deeply considering exploration. I was born in the Bahamas on a tiny island, so going to the North Pole was a way for me to learn more about who I was. The North Pole sits on an ice shelf, which is slowly moving across the Arctic Ocean. When explorers reach the Pole and put a flag in the ground, this large piece of ice has already moved to a slightly different location seconds after the flag is planted.

Each of these three works questions the nature of our relationship to the truth. It is really hard to be human without having a relationship to storytelling. Storytelling has been central to every significant movement spanning the history of art. Culture is formed as a result of storytelling, which encompasses all the things that we try to hold onto and share with the next generation. So what happens when historical narratives are false? What do we with that?

— *Statement by the artist*

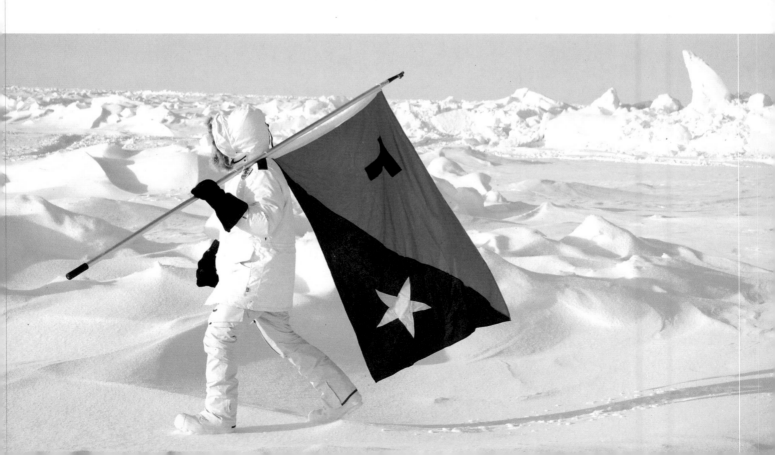

Standing Alone, 2013
Light boxes and Duratran prints
Lightbox 1: 12 in. x 7 ft. 11 ½ in. x 2 in. (30.5 x 242.6 x 5.1 cm);
lightbox 2: 12 x 45 ½ x 2 in. (30.5 x 115.6 x 5.1 cm)
Courtesy Tavares Strachan

Who Deserves Aquamarine, Black, and Gold (FLAG), 2005–06
Hand-sewn cotton
38 x 58 in. (96.5 x 147.3 cm)
Edition: 4, plus 1 artist's proof
Liz & Jonathan Goldman

Sometimes Lies Are Prettier, 2017
Blue neon and three transformers
20 in. x 7 ft. 11 in. x ⅜ in. (50.8 cm x 241.3 cm x 8 mm)
Edition: 9, plus 2 artist's proofs
Courtesy Tavares Strachan

MEG WEBSTER

Throughout her decades-long career, Meg Webster has returned to natural materials to create living sculpture. Using grasses, flowers, plants, soil, and water as her chosen medium, she both nurtures plant and insect life while paying homage to the aesthetic qualities of the natural world. The growing threat that climate change presents to the ecological health of the planet motivates the design of her work. As Webster has said, "I have a great concern for the ecosystem. . . . How do you get people to care about the birds and the bees and the insects? . . . It's hard, when in order to live in this society, you often need to drive and keep an orderly lawn and landscape. I find myself asking, 'Where's Thoreau, where's Walden?' Nature is out there, but it's not going to be out there for long, unless we control our carbon."

For her project *Growing Under Solar Panels*, newly created for Storm King, the artist proposes a new possibility for growing practices. Four solar panels suspended above fourteen growing beds power bubbling water in two small nearby ponds resplendent with water lilies. The rectangular solar panels, which are angled along a north-south corridor in order to best capture the sunlight, mirror the repetition of the rectangular growing beds, giving the work a proud sculptural presence. Planted in the growing beds are a number of vegetables and herbs as well as a selection of plants intended to sustain a lively community of pollinators.

The project is patterned after the work of Dr. Stephen Herbert, professor of agronomy with the Stockbridge School of Agriculture, located at the University of Massachusetts Crop and Animal Research and Education Center. Herbert partnered with David Marley of Hyperion Systems, a company that specializes in large-scale solar power production, to design the solar panel mounting system for the UMass Student Farm. By lifting the panels high and leaving ample space between them, Herbert and Marley found plants grew at nearly double the rate per unit area during a given season compared with growing in the open. Webster consulted the two scientists for the specific height and angle of the panels' placement for her work at Storm King in order to achieve the same growth results. Drawing inspiration from such recent scientific studies, Webster posits a sculpture that is not only a visual and material invitation to consider the interdependency of the environment and human life, but a pragmatic model of nurturing and sustaining this relationship for years to come.

— *S. D.*

Growing Under Solar Panels, 2018
Solar panels with raised growing beds, pond,
and nectar plants for bees
13 x 18 x 40 ft. (396.2 cm x 548.6 cm x 12.2 m)
Courtesy the artist and Paula Cooper Gallery, New York

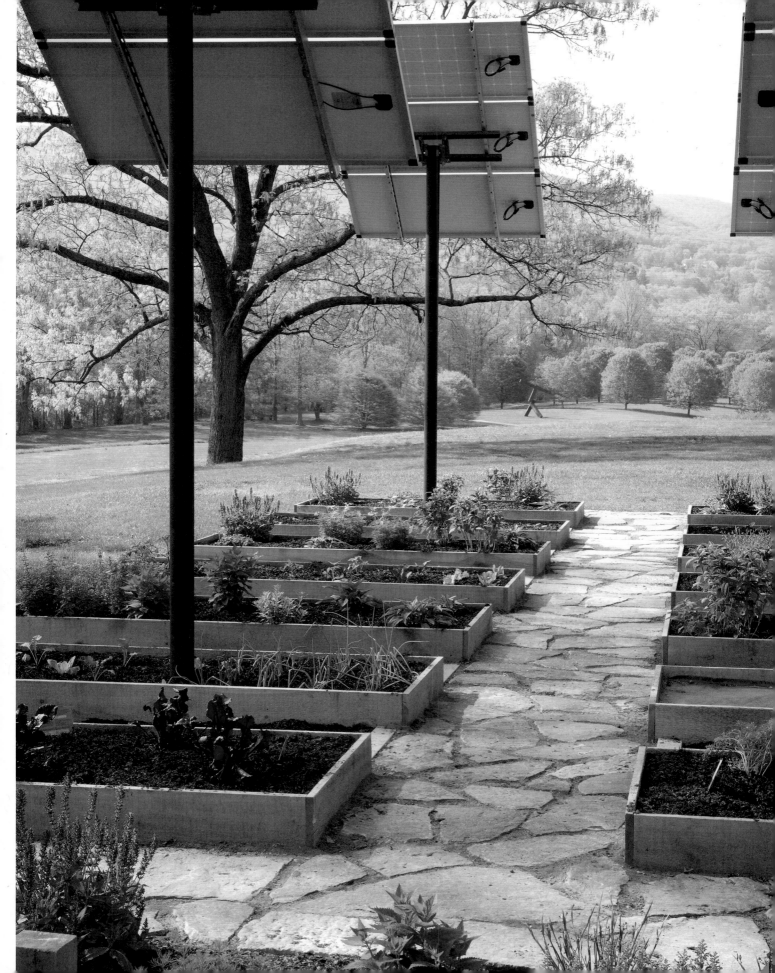

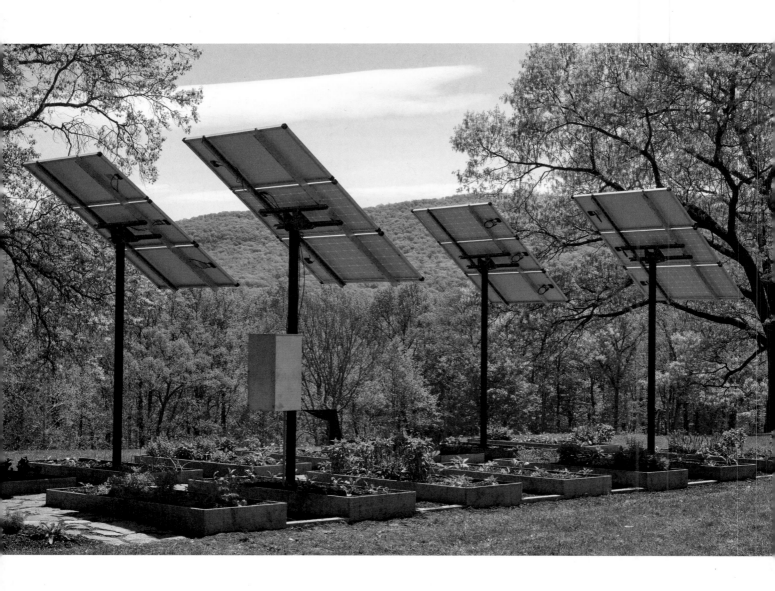

Growing Under Solar Panels, 2018
Solar panels with raised growing beds, pond,
and nectar plants for bees
13 x 18 x 40 ft. (396.2 cm x 548.6 cm x 12.2 m)
Courtesy the artist and Paula Cooper Gallery, New York

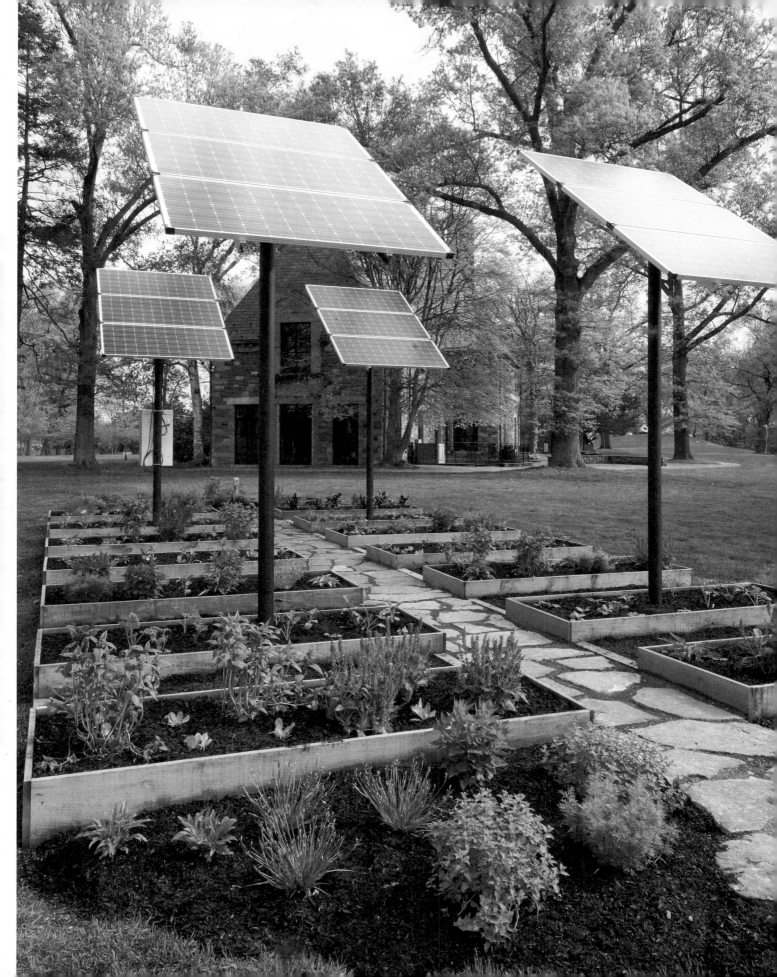

HARA WOLTZ

Vital Signs is an interactive weather station consisting of ten elements fabricated from aluminum and wood. The nine cylinders that form the outer circle of the installation reference the ice cores that are drilled out of the depths of polar ice sheets that are one of the primary ways that paleoclimatologists study climate history. I'm fascinated by the idea of reading history through these cores, and the idea of a particular language of ice. A weather station mounted to the top of a twenty-foot pole extends from the tenth cylinder, where a number of scientific instruments collect real-time data.

Encountering the piece in the landscape, visitors find a series of increasingly higher cylinders rising up out of the ground. Predictions of Arctic sea ice melt by decade inform both these changes in height as well as the progressively different surfaces of the cylinders. Each horizontal surface has a different ratio of blue and white. The lowest surface is all high-gloss white wood and the highest surface is all matte blue aluminum. On the seven cylinders between these extremes, blue areas increase in size as white areas diminish by thirteen percent per cylinder. The percent change in white area reflects the approximate predicted decrease in Arctic sea ice per decade. Concurrently, as the white surface area shrinks, each cylinder rises 33 millimeters [more than 1 ¼ inches] according to a prediction of sea level rise per decade, though it now seems that this predicted increase may occur more rapidly than expected.

The Arctic is warming twice as fast as the rest of the planet, and the surface materials in the work interact to highlight one of the reasons for that: the Arctic amplification effect. The ice in the Arctic functions both as a holder of frozen water and as a reflective surface. As that ice melts, dark-colored water and land emerge and take up more surface area. Instead of reflecting heat back into the atmosphere, the water and land absorb it, speeding up the heating and melting processes. By touching and sitting on the surfaces of this piece, visitors may register these temperature differentials through a bodily experience.

The surface of the central cylinder, on which the weather station is mounted, is mirrored aluminum, reflecting the faces of visitors and the proximate landscape and sky. The instrument at the top of the pole gathers real-time climate data—including air temperature, precipitation, barometric pressure, humidity, wind speed, and wind direction—from its location at Storm King Art Center. This data is accessible through a display console and online. With this work, you can engage with interconnected phenomena across time and distance, and sit in the microclimate of a place, experiencing the piece and the landscape and whatever the weather of the moment might be.

I think that human brains sometimes have difficulty processing complex and unpleasant truths that are nonlinear and occur across broad temporal and spatial scales, as is the case with many ecological and environmental issues. Responding to that, I've created a piece that encourages people to turn toward the gathering of data, to pause, sit, touch, and interact with it.

The title of the work relates to an idea of measuring for the health of a system. Most frequently, vital signs are taken in a medical setting and are used to monitor the bodily ecosystem of a patient.

I was drawn to this idea of climate instruments as medical measuring devices and the planet as an entity. Additionally, this title nods to NASA's climate change Web portal, where they post reports on the vital signs of the planet.

The landscape of Storm King provides an ideal place to reflect on climate change. It's a mosaic landscape formed from a mix of meadows, forests, ponds, and streams, and it's a place where people come specifically to immerse themselves in the intertwining of landscape and art. So much of the sculpture here interacts with the weather patterns, including kinetic pieces that move in the wind. Some only move in heavy wind, and some move in the slightest breezes. The weather profoundly impacts a visitor's experience. Every time I come here, what I notice changes depending on the season and the weather patterns on a particular day. If it has just rained, I may see reflections of sculptures and trees and clouds in puddles. If it is overcast, I perceive the colors of the sculptures differently than on a summer day with bright blue skies. In the winter, I can see microclimates through the way that snow melts first on the south side of Maya Lin's *Storm King Wavefield* (2007–08). In the late spring, I may notice how male red-winged blackbirds stake out territories and interact with certain sculptures more than others. When the meadows are in full bloom, black-eyed Susans add yellow to the landscape and shift the way my vision interacts with the reds of certain sculptures. And, as in most places, the signs of a shifting climate are evident at Storm King in terms of seasonal timing and changes in ecological patterns.

Environmental change is happening so rapidly that every way of paying attention to the world seems necessary. Much has been written about the power of art to reveal the unseen or overlooked, and to catalyze dialogue and action. To me, the poet Alison Hawthorne Demming summarized this well when she wrote in *Zoologies*, her collection of essays, "Art weaves connective tissue between fact and feeling." Climate change can be abstract and nonlinear and it may be difficult for humans to emotionally connect to mostly invisible atmospheric particles and far-off places. Art allows us to connect to these things viscerally. Art in particular has the potential to reveal something that you might not have considered before, to elicit an emotional response, and make aspects of climate change more vivid. I don't know what the future holds, but I do know that this moment is one of tremendous biotic loss and ecological upheaval. I find myself in the camp of many artists and writers and scientists who feel a profound need to bear witness to what is happening on the planet right now, to not turn away, no matter how painful it might be sometimes to continue engaging.

— *Excerpt from an interview with Storm King Art Center*

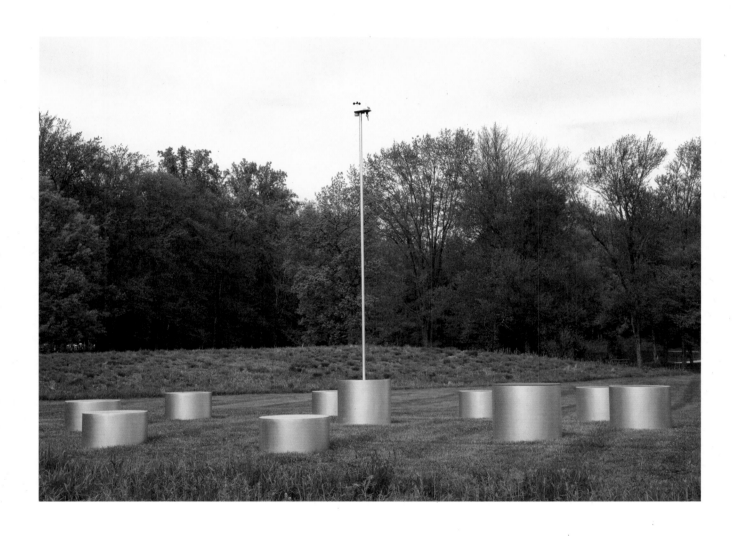

Vital Signs, 2018
Weather station, painted aluminum, mirrored aluminum, and wood
20 x 30 x 30 ft. (609.6 x 914.4 x 914.4 cm)
Courtesy the artist

EXHIBITION CHECKLIST

OUTDOORS

David Brooks
American, b. 1975
Permanent Field Observations, 2018
Bronze
Dimensions variable
Courtesy the artist
pp. 4–5, 25–27

Dear Climate
(U Chaudhuri, F Ertl, O Kellhammer, M Zurkow)
American collective, 2014–ongoing
General Assembly, 2018
Circle of printed nylon flags on wood poles
12 ft. (365.8 cm) high, 84 ft. (25.6 m) diam.;
each flag 60 x 36 in. (152.4 x 91.4 cm)
Courtesy the artists
pp. 8–9, 30–31

Mark Dion
American, b. 1961
The Field Station of the Melancholy Marine Biologist, 2017–18
Mixed-media installation
16 ft. 2 ¾ in. x 24 ft. 1 ½ in. x 9 ft. (494.7 x 735.3 x 274.3 cm)
Courtesy the artist and Tanya Bonakdar Gallery, New York
pp. 6–7, 34–35

Justin Brice Guariglia
American, b. 1974
We Are the Asteroid, 2018
Solar-powered LED highway message sign,
gilded with 23.75K rosenoble gold
Text: Timothy Morton, 2018
15 ft. 6 in. x 11 ft. 6 in. x 13 ft. 3 in. (472.4 x 350.5 x 403.9 cm)
Courtesy the artist
pp. 42–43

Allison Janae Hamilton
American, b. 1984
The peo-ple cried mer-cy in the storm, 2018
Tambourines and steel armature
18 ft. x 36 in. x 36 in. (548.6 x 91.4 x 91.4 cm)
Courtesy the artist
pp. 22–23, 46–47

Jenny Kendler
American, b. 1980
Birds Watching, 2018
Reflective film mounted on aluminum on steel frame
9 ft. x 40 ft. x 12 in. (274.3 cm x 12.2 m x 30.5 cm)
Courtesy the artist
pp. 12–13, 50–51

Maya Lin
American, b. 1959
The Secret Life of Grasses, 2018
PVC tube, lightweight soil, grasses (big bluestem
[*Andropogon gerardii*], switchgrass [*Panicum vargatum*],
and kernza [*Thinopyrum intermedium*]), oak, cable, and steel
Each tube 10 ft. (304.8 cm) high, 12 in. (30.5 cm) diam.
Plants courtesy The Land Institute, Salina, Kansas
Courtesy the artist
pp. 14, 54–55

Mary Mattingly
American, b. 1978
Along the Lines of Displacement: A Tropical Food Forest, 2018
Paurotis palm (*Acoelorrhaphe wrightii*), ponytail palm
(*Beaucarnea recurvata*), and coconut palm (*Cocos nucifera*)
from agricultural zones 8 and 9 transplanted to zones 4 and 5
60 x 50 x 22 ft. (18.3 m x 15.2 m x 670.6 cm)
Courtesy the artist and Robert Mann Gallery
pp. 58–59

Gabriela Salazar
American, b. 1981
Matters in Shelter (and Place, Puerto Rico), 2018
Coffee clay (used coffee grounds, flour, salt), concrete block,
wood, and polypropylene mesh tarp
12 x 16 x 20 ft. (365.8 x 487.7 x 609.6 cm)
Courtesy the artist
pp. 73–75

Meg Webster
American, b. 1944
Growing Under Solar Panels, 2018
Solar panels with raised growing beds, pond,
and nectar plants for bees
13 x 18 x 40 ft. (396.2 cm x 548.6 cm x 12.2 m)
Courtesy the artist and Paula Cooper Gallery, New York
pp. 85–87

Hara Woltz
American, b. 1971
Vital Signs, 2018
Weather station, painted aluminum, mirrored aluminum,
and wood
20 x 30 x 30 ft. (609.6 x 914.4 x 914.4 cm)
Courtesy the artist
pp. 90–91

MUSEUM BUILDING

Ellie Ga
American, b. 1976
At the Beginning North Was Here, 2009
Digital video and stop-frame photography (color, sound)
7:18 min.
Edition: 5, plus 1 artist's proof
Courtesy the artist and Bureau, New York
p. 38

Map of the World, 2007
Marker on wall
Dimensions variable
Edition: unique
Courtesy the artist and Bureau, New York
p. 39

Remainder, 2010
Gelatin silver print
17 x 17 in. (43.2 x 43.2 cm)
Edition: 10, plus 2 artist's proofs
Courtesy the artist and Bureau, New York
p. 39

The Cast (502 Days), 2011
Cast white brass
9 x 1 ¾ x ½ in. (22.9 x 4.4 x 1.3 cm)
Edition: 3, plus 1 artist's proof
Matthew Gribbon
p. 39

The Deck of Tara, 2011
Fifty-two unique playing cards and booklet in wooden box
Box: 1 ½ x 4 ½ x 3 ¼ in. (3.8 x 11.4 x 8.3 cm);
installation dimensions variable
Edition: 10, plus 2 artist's proofs
Courtesy the artist and Bureau, New York
p. 39

Justin Brice Guariglia
American, b. 1974
Mining Landscape (No.132/Cu), 2018
Copper, acrylic, epoxy, and aluminum panel
40 x 30 in. (101.6 x 76.2 cm)
Courtesy the artist
p. 41

Agricultural Landscape (No.131/Au), 2018
22K gold leaf, acrylic, gesso, linen, and aluminum panel
40 x 30 in. (101.6 x 76.2 cm)
Courtesy the artist
p. 41

Mining Landscape (No.130/Au), 2018
24K gold leaf, acrylic, gesso, linen, and aluminum panel
40 x 30 in. (101.6 x 76.2 cm)
Courtesy the artist
p. 41

Agricultural Landscape (No.133/Ag), 2018
Silver, acrylic, epoxy, and aluminum panel
40 x 30 in. (101.6 x 76.2 cm)
Courtesy the artist
p. 41

Jenny Kendler
American, b. 1980
Underground Library, 2017–18
Selections from a library of books on climate change, biocharred to sequester carbon
Dimensions variable
Courtesy the artist
p. 49

Maya Lin
American, b. 1959
59 Words for Snow, 2017
Paperboard, encaustic, and aluminum
53 ⅛ x 50 ¾ x 2 ½ in. (134.9 x 128.9 x 6.3 cm)
Artist's proof
Courtesy the artist and Pace Gallery
p. 53

Before It Slips Away, 2017
Paperboard, encaustic, and aluminum
54 ¾ x 65 ⅝ x 2 ½ in. (139.1 x 166.7 x 6.3 cm)
Edition: 2
Courtesy the artist and Pace Gallery
p. 53

Alan Michelson
Mohawk, b. 1953
Wolf Nation, 2018
High-definition video (color, sound)
9:59 min.
Sound by Laura Ortman
Courtesy the artist
pp. 62–63

Mike Nelson
British, b. 1967
Eighty circles through Canada (the last possessions of an Orcadian mountain man), 2013
35mm slide projection (eighty slides), 50mm lens, ply-driftwood, plywood sheets, metal chains, and the remaining personal effects of Erlend Williamson (deceased)
Shelf and screen: 9 ft. x 13 ft. 6 in. x 15 in. (274.3 x 411.5 x 38.1 cm)
Courtesy the artist and 303 Gallery, New York
pp. 10–11, 66–67

Steve Rowell
American, b. 1969
Midstream at Twilight, 2016
Single-channel video (color, sound)
20:00 min.
Courtesy the artist
pp. 70–71

Rebecca Smith
American, b. 1954
Maquette for Weather Watch, 2013
Steel, plywood, and mycelium by Ecovative
66 x 28 x 28 in. (167.6 x 71.1 x 71.1 cm)
Courtesy the artist
p. 79

Tavares Strachan
Bahamian, b. 1979
Who Deserves Aquamarine, Black, and Gold (FLAG), 2005–06
Hand-sewn cotton
38 x 58 in. (96.5 x 147.3 cm)
Edition: 4, plus 1 artist's proof
Liz & Jonathan Goldman
p. 80

Standing Alone, 2013
Light boxes and Duratran prints
Lightbox 1: 12 in. x 7 ft. 11 ½ in. x 2 in. (30.5 x 242.6 x 5.1 cm); lightbox 2: 12 x 45 ½ x 2 in. (30.5 x 115.6 x 5.1 cm)
Courtesy Tavares Strachan
p. 81

Sometimes Lies Are Prettier, 2017
Blue neon and three transformers
20 in. x 7 ft. 11 in. x ⅜ in. (50.8 cm x 241.3 cm x 8 mm)
Edition: 9, plus 2 artist's proofs
Courtesy Tavares Strachan
pp. 82–83

STORM KING ART CENTER YEAR-ROUND STAFF

Mary Alva

Deanna Bolin

Amy E. Brown

Irene Buccieri

Amanda Burris

Jessica Dawn Carey

Mary Ann D'Egidio Carter

Rachel L. Coker

David R. Collens

Michael Cook

Anthony J. Davidowitz

Hannah Walsh des Cognets

Sarah Diver

Annie Ducham

Sarah Dziedzic

Nancy Ferryall

Olga Filakouris

Robert Finch

Brielle Gerrity

Ellen Grenley

Dwayne J. Jarvis

Miranda Kozak

Nora R. Lawrence

Victoria Lichtendorf

Joel Longinott

Rhema Mangus

Susan McCallop

Natalie McKinstrie

Anna McLeod

Lillie McMillan

Cara Nuzzo

Armando Ocampo

Florencio Ocampo

Michael Odynsky, Jr.

Tia Padget

Christine Persche

Matthew W. Romary

Adrianne L. Savino

Howard Seaman

Mike Seaman

Maureen Spaulding

John P. Stern

Sara Umland

Jacob Vitale

Stephanie Watkins

Amy S. Weisser

Samantha Wiley

Sara J. Winston

Amy Zaltzman

Colleen A. Zlock